headpress

Headpress *The Gospel According to Unpopular Culture*
www.headpress.com

CAVEAT

This is a remodelled Mk II version of
HEADPRESS 28. The plates for the original
HEADPRESS 28, ready for the printers, were
destroyed in the night by fire by monster
dogs, or "Headpress Panthers" as they call
themselves. A spokesperson for the "Pan-
thers" said nothing, but it is understood
the action was a protest against the abun-
dance of colour in the original edition,
what the Panthers considered "a triumph of
form over content". Sixteen pages salvaged
from the fire appear in the middle of the
book you are holding.

HEADPRESS 28 marks the fortieth anniversary
of the original White Panthers movement.

Contents

||

An appointment with John Sinclair in the city of Amsterdam.

by David Kerekes

JOHN SINCLAIR, one time manager of the MC5 and leader of the White Panther Party, was sentenced to ten years in prison in 1969 for giving two joints of marijuana to an undercover cop. His case received international attention when JOHN LENNON immortalised him in song and performed at a benefit on his behalf in 1971, along with STEVIE WONDER, ALLEN GINSBERG and others. Three days later John Sinclair was set free.

Those too young to remember the sixties may have first encountered the name John Sinclair on the 1972 John & Yoko/Plastic Ono Band album Sometime in New York City. In 2007, on the re-release of John Sinclair's book Guitar Army, its UK distributor suggested a meeting between Headpress and Mr Sinclair with a view to perhaps an interview. The interview never really took place as fate had decided on a different dance. Instead, through laughter, the discovery of inner continents of common ground and a realisation that the man outshone the myth, Mr Sinclair revealed his true credentials: a heavyweight jazz and blues expert, a man of whom AMIRI BARAKA said: "Hell, there's a buncha wooden negroes much whiter than John."

AN APPOINTMENT WITH JOHN SINCLAIR

John travelled from his home in Amsterdam to visit the Headpress Bunker on several occasions and by mutual joy became Headpress senior editor. In January this year, Headpressmen DAVID KEREKES and CALEB SELAH, the fabled service engineer, met with John in Amsterdam to turn talk into tactics and strategies.

CALEB SELAH: "The Dutch were empire builders, early ones in Europe. They were seafaring explorers and gentle traders as opposed to the greedy syphilitic Spaniards and that good old nation of shopkeeping hooligans, the English. Their imperial fallout resulted not in national guilt (like the French) or pragmatic cowardice with scant regard to consequences (the English again) but mature legislation designed to create social justice, not merely use it as a sound bite. This led to the multicultural tolerance that allowed Amsterdam to become for some the most civilised city in the world and for others (mainly the Dutch), an increasing pain in the ass. The social and cultural history of the country could have been a template for all, but then fundamentalist abusers intervened with a gun and killed Theo Van Gogh, a Dutch filmmaker who was in the process of working with Hirsi Ali, a Dutch assimilated Somalian woman who wrote the book The Caged Virgin (an inside view of the horrors of the lives of many Moslem women). The Dutch people I have met have invariably been polite, witty and converse in embarrassingly well elucidated English. Sadly they are also developing an increased intolerance towards the manifestations of fundamentalism and paradoxically the cultural reaction to these attacks on freedom of speech has given the Dutch protestant reactionaries a louder voice.

"Amsterdam is the jewel of the Netherlands and attracts the rural Dutch on Queen's day, which is April 30. That is pretty much only time of year there are no Sleasyjet injections of foul doses of vile groups of British cultural ambassadors who do their very best to uphold a well deserved reputation as noble open minded travellers. The Dutch prove their tolerance by not kicking the crap out of them at every opportunity. It isn't pretty though, as we shall see."

ONE

NO RIGHT MINDED person travels to Amsterdam on the tail end of a Saturday evening, only those in the know. Stanstead airport is unusually silent, punctuated by the muted pacing of a listless Cal on soulless linoleum. As ever he is determined to get a window seat even though it has been dark for hours. Inevitably our flight departs late and arrives at Schipol airport before it was meant to. From here we travel by train to Amsterdam central station and catch a cab to the Dolphins coffeeshop, where we have an appointment with John Sinclair, the famous ex felon. He committed the heinous crime of giving two joints of marijuana to an undercover police woman on the day Caleb Selah was born. So?

The name of the cab driver is Hassan and he engages us in some blatantly transparent questioning designed to establish the level of our gullibility and wealth. He hands a block of dope to Caleb and suggests he roll a joint while he transports us to our destination. *"Yeah, right!"* I yell and roll my eyes, picturing a repetition of one of our Mexican situations. I consider leaping out of the cab but it's only doing four miles an hour. Cal calmly hands the block and the rolling papers back, telling Hassan that it is dark, the car is moving, the reason he is wearing sunglasses is because he is in effect blind at night time and he only ever skins up with Zig-Zag papers while watching old Joel McCrea or Randolph Scott movies on TV. Amsterdam is not the place for twilight activity in the back of a cab. What's the point? Cal will have none of it. His game plan is to get high on the finest dope in Amsterdam, the stuff they keep back from the tourists; he is eagerly anticipating what a man with Mr Sinclair's reputation can procure. Disappointment he says is simply not an option as he fantasises about substances I have never even heard of and certainly sound a lot stronger than cannabis.

"I've got a beard trimmer," Caleb tells me, ignoring Hassan.

"Have you?" I ask. "With you?"

"No," he says. "I was worried that airport security may think I was going to trim the pilot's eyebrows once we were airborne." And, in a pinched accent: *"Take us to Cuba, otherwise I trim your eyebrows!"*

"That would be quite an affront to some men," I determine.

"Indeed," Cal muses, "especially a pilot."

"And barristers." I remember a story a barber once told me. "Barristers cultivate big eyebrows and tufts of hair in the ears and in the nose. It's a sign of —"

"Walrusness."

"Some kind of legal —"

"I don't believe this for a second," Caleb snaps, leaving Hassan with his fare and a tip. "This is bunkum. You've been led a merry dance, my friend."

"No. It's legal standing," I respond.

"It's an urban legend."

"A hairy leg end, perhaps, but not an urban one."

SUSPENDED FROM the ceiling of the Dolphins on a wire is a life size papier-mâché dolphin, which is not cute or clever. Everything is painted blue with ambiguous sea fauna and the walls are a coral reef constructed from polystyrene bricks and chicken wire that juts precariously close to my head at every turn. I'm not high. I'm not making this up. The Dutch greet one another in this undersea kingdom with a kiss upon the cheek three times, a bit of a malarkey for a large group of people in such a confined space. "Avoid eye contact," I whisper to Cal, whose eyes are on the counter avoiding the girl behind it. "Her pigtails are there to fool you. They hide a mean disposition and probably scales."

The point is then proven by the mildly malicious manner in which Cal is informed that wearing sunglasses is neither cute nor clever after midnight.

"My eyes are tired. What's your best hash?" he asks.

"We only have grass," snarls the attractive but truly quite scary server person.

"Ok, I'll have a mixed pre rolled spliff, please."

"Do you get it?" Cal says to me, in possession of one Apollo Weedjoint and marvelling at its structural perfection and then igniting it. Ashes to ashes. Skunk to skunky.

"It's all sea, as you can see, you see," he adds whilst subjecting me to his exhaust fumes.

Yes, I get it. I would also like to get a beer but I can't get beer now that alcohol in coffeeshops is forbidden under a new law. Well, it's an old law that everybody chose to ignore until recently. Coffeeshops can sell soft drugs or, you guessed it, coffee. Bars sell alcohol but not drugs, but a tiny few will allow you to smoke a spliff in their bar.

John Sinclair arrives in the Dolphins after fifteen minutes. This is John's natural habitat. He flits to the United States less frequently these days. When we meet him in Dolphins it is January 19 and he is packed ready to fly to New Orleans for the Mardi Gras and his annual Two Stick residency in Oxford, Mississippi. It remains one of the few absolute necessities that will motivate him to leave the city that always sleeps.

The smoking ban comes into effect in July and we inquire as to whether or not this would be used to stop people smoking in the coffeeshops.

"The government has said it will not use this as a lever to close the coffeeshops," John muses from his favourite spot, by the window. Tim, a criminologist, joins us.

When people talk of Amsterdam it is with a nudge and a wink. This is, after all, the city of hash and hookers, of legal highs and red high heels. Guys from Britain go on weekend breaks to Amsterdam in intimidating packs, and the temptation of anal sex when they arrive makes them go berserk. Tim explains this with a wry smile and hands me his business card. I look at it closely, expecting to get out of jail free.

John continues: "The Dutch hate the coffeeshops and the culture that goes with it and the kids. They are going through a cultural reaction against their previous multiculturalism as a direct result of the attacks by Islamic fundamentalists who have assassinated politicians and artists whom they consider to be a threat to their beliefs. The Dutch are businessmen; they want Amster-

dam the theme park, with families and culture vultures, not people who enjoy the thrill of legal consumption of what is prohibited at home.

"If they announced they were going to go after the coffeeshops, I wouldn't be surprised. They are on a tremendous roll of right wing culturalism, mostly because of the Muslims. They are using that as an edge to press their Christian values."

His voice slows to a crawl. The health warning on a packet of Dutch Silk Cut Purple translates as *Avoid smoking near to your toes.*

"Now the government is engaged in this fucking thing to clean up the red light district. They want to shut down the red light district; they want to make it a first class tourist destination. It's all under the name of combating the inroads of organised crime. They tried to declare the Hell's Angels a criminal organisation. They lost. Buildings with squares of windows — they'll convert those to other uses, selling them to hotels by the people lined up to promote this shit. It's all so fucking ugly. I'm trying to get away from this kind of shit to somewhere where they don't care if people are fucking and getting high, somewhere where I fit in. Although I must confess my fucking days are a pale shadow of their former self."

"By the way," I interject. "Leni was very helpful."

"By the *way*?" says John.

"By the way," says Cal. Cal suddenly appears to have a bad cold; the weed he is smoking does his hay fever no favours. Grass is pollen.

"By the way," says John with a smile that becomes a long laugh that rattles the coffee cups, "speaking of fucking — in the context of my carnal activities — it's been a long time since we've done any fucking…"

TWO

IN THE Dolphins the sea fauna is not moving when a hopeless fruitcake in comfortable slacks and a beret declares from behind his MacArse that Bob Holness, the saxophonist on the Gerry Rafferty song, Baker Street, is trying to kill himself on Facebook. "It's a great sax solo!" he wails and people around him all

agree. But it isn't a great solo, is it? It's a very *long* sax solo. In the pantheon of top heckles, shouting "Baker Street!" whilst idiots wrestle with jazz sits right alongside shouting "Judas!" at any twat with an acoustic guitar. This observation doesn't sit too well in the room and Gerry Rafferty fan #1 moves swiftly on to the US election process, which is a sham according to a clip uploaded on YouTube. TV is passé and who are we to disagree? Everyone it seems has a MacFart and everyone lives their life on it. Or they share in the lives of others on internet radio and internet blogs and store the recent past in podcasts.

John is strictly a coffee and dope man, and he puts away strong black coffee like a barfly chases shots of liquor. The young ladies who work at the Dolphins serve him an espresso on the house every two minutes whilst upgrading our service to that of honoured guests. What do they know of John Sinclair? He is the Official Poet in Residence at the Dolphins Coffeeshop and has free accommodation provided by the owner, they know that much. They also know he has a radio show, and who knows, some of them even think he may have shot John Lennon. When the music coming out of the Dolphins' sound system slips into a Beatles track (Strawberry Fields Forever) one of the regular customers picks his head out of a book long enough to ask what is playing. It isn't eurotrance. John loves the Dolphins but he filters out the music they play. It isn't the sound of the crossroads.

Caleb asks whether there is a market for the blues, specifically referring to John's ongoing project *Fattening Frogs for Snakes*, which is a series of poems telling stories of the blues greats set to awesome playing and over it John's sixties beatific bop prosody. "*Market*?" John says, twisting the word to fit a small box labelled fat frogs. A conceit as modern and vulgar as market may not be applied to a love so supreme.

"Market," John sneers, and he says no more on the matter.

THREE

IN ORDER to escape the mind altering tedium of passive smoking in the Dolphins I bid my leave to Caleb and John and John's producer, Larry, and pos-

it myself in a north-westerly direction towards alcohol. I am in Dam Square toasting the grey stains of the day when I encounter a Brit parade from the West Midlands. I hear them before I see them, yelling over a CNN anchorman like Noddy Holder at Christmas time. (He uses the expression "Super-duper Tuesday" and so deserves nothing less.) We discover a common background in the business of plumbing supplies and our mutual knowledge of GF fittings helps galvanise friendship through lager. The reason the lads are in Amsterdam is a stag do for Stevo. The very name elicits a chorus of cheer and abuse.

"Where is Stevo?" I inquire after five bars, realising that I haven't so much as seen the "cunt" and would like to buy him a drink.

"You can't," says Wayne, the tallest member of the group. "He got fuckin' deported, didn't he?"

Wayne regales me with the details: Stevo, hung-over in Bilston, missed the scheduled flight out and crawled onto a later flight, finally arriving in Amsterdam pissed as a newt. Upon leaving Schiphol airport he immediately jumped into the driver's seat of an empty tour bus "for a laugh" and got promptly escorted to the next plane back to Britain. He was on Dutch turf no more than twenty minutes. "The bastards fuckin' did him," sputters Wayne. "Now he's missing his own holiday." The story is a sad one it's true and I raise a glass to lead my company in another chorus of "*Steve-o!*"

The red light district, which starts at the train station and crawls down one laddered seam of the city centre, is a sleazy enough apparition by night but by day it is uglier than a scagwhore's undergarments, attracting only the most desperate of perverts and louts like us, bracing for a scrap. Twilight has driven us to the sex stores, where a rudimentary examination of the films on display defines sex in the twenty first century as a series of obtuse paraphilias. DVDs with titles like *Crazy Knickers* and *Toes in Turmoil* have the lads from Bilston yearning for the good old days of porn with eels and horses that do scat. You know, the honest to goodness repulsive stuff.

"I can't wank to this," says Wayne, clutching a DVD whose cover implies the use of a grandmother and a Champion sparkplug.

Amsterdam is changing rapidly. More than the increasing prices and smell of piss, international fashion may well be the end of the red light district as we know it. Fashion has no truck with filth, if one is to believe the local news. Property that was recently confiscated from a notorious crime lord has been handed by the government to young fashion designers, rent free for one year. This is the first step in the non sexual regeneration of the red light area and marks the launch of International Fashion Week, which coincides with our arrival in the city. In some buildings, windows that once displayed prostitution now display only a chemise and stylish footwear. It spells confusion for my crew from Bilston, and we quickly rally to the sanctity of the live porno emporia on the next block, where sex is as it should be and the hawkers of flesh sing the sweet music of the night: *"This way, gentlemen, for the freshest pussy in town."*

We slap down money for the banana show when a doorman convinces us the price of entry includes as much beer as we can drink. It's the perfect pitch for a drunken mark. But twenty minutes later the sorrowful and humiliating spectacle of "Alene" and her over ripe fruit is over, and so too our endless supply of beer. "This is shit!" moans Wayne back on the street. He takes his frustration out on a tiny tourist and brawls with the police who arrive to take him away before vomiting. The rest of the crew disperse in an alcoholic reverie: some go to the next bar, some fall into the canal, and some advise me to stay away from the black whores, because "they'll roll you for every penny."

My sojourn at an end I return to the Dolphins, where Caleb is as I left him. He declares that whilst there is much more to be imbibed it is a matter of pacing oneself, and an hour with Larry, John's producer, is more than enough to put the pace into space. Larry points out his favourite restaurant over the road, the Café de Klos, where you eat at the bar and the ribs fall from the bone with a pop. We should try it sometime. But the Café de Klos is closed and so instead Cal and I eat something with meat at a joint next to the Big Bananas Nightshop. It is schwarma, but the man there calls it "meat." The diner is painted green, matching the rudimentary pigmentation of the linoleum floor and cheap condiment dispensers. We are tired and hungry and while the green meat shop and its orgy of colour isn't the most obvious choice for a late night bite, we are

left no other choice on a late January night in Amsterdam. It rains all the time and is cold all year round except for one week in the month of August. July is not summer in Amsterdam. Forget it. At a green table we sit, where the grey meat man delivers our food, meat, and asks whether "*Is nice?*" This is suspicious. Why does he keep asking me if the meat is nice? The grey man repeats the question right up until the time we have finished our meat and paid for our meat and have left the green meat shop.

I sicken Caleb with my recollection of the banana bar in the red light district, where men awash with booze tried to focus on Alene and her erotic act on the small stage before them.

"This girl called for volunteers and only three people stepped forward," I tell Cal. "She needed a fourth man but nobody else would step forward, and so I said 'Fuck it.'"

"Oh, *please*," groans Cal. If dysentery doesn't finish him my tale might. "Never volunteer for anything."

"I did. I was the fourth man."

FOUR

THE FOLLOWING day we buy a map to take us to the Melkweg for an appearance on a live broadcast of John's weekly radio show. The new law that forbids alcohol in coffeeshops encourages several detours that take us into both bars and coffeeshops, and the better part of the early afternoon. In the Café Krom on a corner of Utrechtsestraat, Dutch enough to escape the packs of Traceys from Scarborough and Arsenal fans who communicate exclusively via the word Gooner, a half soused sailor sings above a sickly French ballad playing on a 1950s style jukebox. His sweatshirt marks him out as being the "king of the five boroughs." A young couple filter the sailor out of their loving, longing gaze. Their casual dignity betrays them as natives, as do their felt hats. On the wall is a poster of a bullfighter with a bull, the type of poster every tourist brought back with them from Spain in 1977. I'm not sure why the bull is as delighted as it appears to be in the poster.

"Perhaps it is because it is receiving the attention it craves at last," says Caleb. "He just doesn't realise he's about to be run through with sharp pointy things. But we all get run through with sharp pointy things to a degree at some point in our lives. [The sailor falls off his stool.] Sometimes constantly. We just don't feel it."

Outside the rain stops only to allow the wind to blow harder, which is a terrible business for a city built just below sea level.

Caleb considers the room and spies food, a frangipane on the table occupied by the tall lovers who share the slice between two forks.

"They've got cake. Why haven't we got cake?" he asks.

"I don't think we ordered any," I reply.

"Is it cake or pie? It's important." He calls over to the couple: "*Is that cake or pie?*" They shrug, as can be expected when language and culinary issues are raised by a big man with a bald head.

"I think you may have wrongly ordered," Cal informs me, bitterly disappointed that our beer is not sweet food or cannabis of any stripe.

I distract him with sambuca and my tale of great importance.

The story begins with a writer going to give a lecture. On his way to the venue, waiting at a train station, he witnesses a funeral passing by. Later, giving his lecture, he recounts the incident but embellishes it so that the lowly funeral car is a splendid horse drawn carriage followed by hundreds of grief stricken mourners. Then he confesses this isn't the way it happened at all. "I am a writer," he says, "and my job is to tell lies." The audience applaud and, as it's a fairly typical film from Paul Verhoeven, the Dutch director of *Basic Instinct* and *Showgirls*, he has frenzied sex with his pretty blonde interpreter soon after.

The film is called *The Fourth Man* and it will have a peculiar resonance through this trip.

The Café Krom, with its sambuca and the menu of tall lovers, is followed by a coffeeshop with a Brazilian façade that actually appears to be Spanish in origin, further on down the road.

"Less to your taste?" asks Caleb, who folds the *Herald Tribune* flat on to the recently drenched and even more recently not cleaned coffee stained table. He

smokes the second most expensive weed on the menu so that it may stimulate his appetite for a better quality product.

In this establishment the list of THC based goodies only appears when a big red button inscribed "PRESS" is pressed. The menu is then illuminated. Pressing a big button may be entertainment for the atrophied monosyllabic morons that gnaw on a bong all day, but it doesn't occupy me for long. Of far more interest is the incredibly detailed fire exit poster on the wall, which involves the use of a bewildering number of doors and seemingly detailed routes through sewers and canals.

"Yes. Less to my taste," I respond, and then we engage in a conversation about the Anne Frank museum, how it is small and how neither of us has been. *Did her father write the diary or merely plagiarise it?* We talk also about the role of Angolan women in the affairs of a country in the face of an expensive war, and Puerto Ricans living in New Jersey. But there is nothing in the *Herald Tribune* about the party favours Caleb hopes John will procure. Caleb, ready for some nice upward stimulation, fantasising about the purity of what surely must be available in the dam to a man of Mr Sinclair's standing, taps into his phone a wakeup text for John: "*Get out of bed you old hippie and get me some interesting shit.*" He then demands the most expensive hashish by far, Isolator, only to be told by the coffeeshop staff there is none. His face expresses the pain and petulance of a spoilt child or perhaps a man on the receiving end of a terrible injustice.

One hour later during lunch at the Hard Rock Café, John reads his newspaper over a hamburger served by a man whose name is Josh. "The wire is twitching," John tells Cal about the procurement of further party treats.

"Is that a good thing or a bad thing?" Cal asks. I shrug. Is a twitching wire a good or a bad thing?

Cal has not yet recovered from the indignity and incapacitation caused by the use of a Vaporiser, a contraption that changes the physical state of grass by heating it until the good stuff is released but before it burns. No tobacco, no carcinogenic risk, perhaps even a fighting chance of giving up cigarettes.

I watch Cal suck on a prophylactic sheath the length of his arm while he pretends it is not there.

Larry is the man to talk to about the cannabis culture's hardware. Endlessly. To me. The non smoker. The only saving grace is that whilst I am being assailed by facts about a subject that is of no particular interest to me, at least I am temporarily removed from Cal's soporific exhaust fumes. I nod as I am informed it is no longer quite so easy for the novice to accidentally detach the mouthpiece of a Vaporiser, should he or she fold up the balloon like a dying tube of toothpaste to extract that last bit of air. The nozzle will not fly free as once it might under pressure. The rubber o-rings that used to attach the balloon to the mouthpiece have been replaced with a more effective quick locking mechanism, keeping the nozzle secure. Larry had plans to buy a Homer campervan in Connecticut on the day he blew it for two bags containing WiFi equipment and a trip to Holland. His facial hair growth defines him even more accurately than mine. He has since become what you or, more specifically, he, might call a handyman of the airwaves. Some people play music in return for a meal or give a painting away; Larry puts them on internet radio. In the Melkweg on Marnixstraat, our final destination, he is busy recording The Empty Bowl, a cookery slot from the Melkweg's café-restaurant, Eat At Jo's. Which everyone who visits the Dam should do. The logo for Eat At Jo's is an all-American mom with a hotplate and a mushroom cloud rising behind her out the window. Larry finishes up and digs out a telephone number to help John help Caleb with the business of pharmaceutical research. Larry carries no less than eight varieties of dope on his person at any given time but nothing else. Class A substances are illegal. "The wire is twitching," Larry says, making the call.

Cal is so puzzled he loses part of his phone.

Larry repeats what the voice on the end of the line is saying: *"I'm eating. I'll call you back."* He then hangs up and places the phone back in his pocket. "I could hear more what he was eating than I heard what he said," he says. Larry has connections but the connections are old and illegal drugs are seriously frowned upon here, in a similar way to smack in the UK. Nonetheless, Caleb will eventually find himself in possession of what bears an uncanny resem-

blance to some form of chalky stone, which may or not be illegal. (He refuses to discuss the matter.)

With a press of a switch on Larry's MacThing the sound of Charlie Parker playing La Cucaracha oozes out across the airwaves to announce the arrival of the John Sinclair radio show. (www.RadioFreeAmsterdam.com) I only have Charlie in one channel of the headphones I am wearing, but it is too late for Larry to do anything about it because the show is live. When La Cucaracha comes to an end, John breathes a mellow *"yeah!"* and cuts the digital silence with his obligatory opening toke:

"It's a beautiful January Sunday afternoon at Eat At Jo's in the Melkweg and our guests are editor David Kerekes and publisher Caleb Selah of Headpress in London, spending a couple of days visiting with me before I leave for the United States and the Mardi Gras on Thursday. We enjoy some good conversation about Headpress and listen to fine music by the New Orleans Jazz Vipers, Kermit Ruffins, Charles Mingus, Beau Dollar with the James Brown Orchestra, Joe Tex, the First Revolution Singers, Jimmy Reed, Thelonious Monk, Howlin' Wolf, and Johnnie Bassett & the Blues Insurgents."

Caleb is pretty wasted with a lot to say but too self conscious to say it, so I had better come up with something. Across the road stands the American Hotel, with its imitation Beardsley prints and a restaurant where a Japanese chef is responsible only for eggs. Someone is detoxing on natural yoghurt at twelve euros a bowl and asking whether it is snowing in Beijing. I ignore the blah blah Headpress question, grab the bull by the horns and embark on a tale of great importance.

"I bought a map today," I tell John and the listeners, leaning into the microphone as advised by Larry. "The lady in the shop asked whether I wanted a cheap map or an expensive map. I asked what the difference was." "The cheap map," said the lady, "has no street names on it."

The sound of a pin drop in cyberspace. At that moment a giant funeral procession rolls outside the window with a hundred mourners on what is the coldest January on record in the city of cheap bicycles.

An American Poet.

by Dylan Harding

TO DECIDE to live your life as a poet in an age when poetry is the least perused form of literature is financially suicidal; to decide to write a history of the blues in verse form is an act of madness; to decide to write a verse history of the blues and then perform and record every single poem with backing musicians and release them on a four cd set along with the book is in fact tantamount to being certifiably insane; to doing all that and doing it as a great work of art is an act of genius. JOHN SINCLAIR'S FATTENING FROGS FOR SNAKES is an epic rendering of the history of a genre that is the life-blood of American music and since its murky inception as a child of debased servitude, has become an influential reserve of artistic inspiration for generations. Like religious folk returning to primary texts to keep themselves in touch with the spirit of their quest, musicians, intent on creating original expressions of humanities day to day living realities, source the blues.

TS ELIOT'S *The Waste Land* is a reflection of the poet's concern and alarm at the disintegration of the values, knowledge and influence of his elite group. In 1922, as modernity, with its ever widening sense of egalitarian principles, began to give aspirations and education to the masses, Eliot drew upon the reserves of his own expensive education and wrote his self-confessed "little gripe against the world". To ensure that we somehow did not miss his point, that the world had lost its way by rejecting Anglo-Saxon Christian supremacy, Eliot laid a dense fabric of historical and intellectual allu- sions that showed his ma and pa that his time at Harvard and Cambridge was well spent. The blues is a unique body of work created in multiple settings by a variety of personalities and has as distinct markers the race of the people it originated from and a birth on US soil. The genius of *The Waste Land* is it captures the mood of a member of the Brahmin elite, fretting between wars, like a little schoolgirl; the early blues as a body of disparate works, captures the experience of those at ground level, releasing creative energy in the absence of the basic tools of self-defence (i.e. sub-machine guns, rocket launchers, even

perhaps the right to vote). The last time I checked (which was about two minutes ago) the elite was still going strong and many of those at the bottom were still hanging on. But let us not fuck around — early blues is poetry and it is the poetry of everyday life as lived by those that lived under the heavy handed tactics of violent racist murderers and systematic state sanctioned segregation. If you put a foot wrong you were dead.

Sinclair's *Fattening Frogs for Snakes* is not the work of a casual listener to the blues, nor is it just the focus of a creative writer looking for "subject matter"; *Fattening Frogs for Snakes* is the result of a participant/activist/scholar/critic rendering through poetry the artistic greatness of the blues. Sinclair can still hear the footsteps of the originators of the blues; his poetry evokes blues humanity as it roams a geography of rivers and deltas; travels railway lines and back roads; gathers in communities against the odds; suffers economic genocide; fears violent death; and creates the most gloriously original sounds ever played. Who were these people that went unnoticed in their lifetime? First and foremost they were poets. No shit! Poets of what? The poetry of trying to be poets of the life they were living. Blues is the poetry of the confrontation between social non-being and exclusion and actually being. Others may pretend you do not exist and treat you that way... but the blues is the brooding narrative that finds your loneliness and like a fire and brimstone preacher reminds you that you are damned there forever with no possible escape. When you have the blues you are in contact with the limitations of your powers to: influence events, escape pain, move on, transcend death, love again or have any hope; and are therefore, fully defeated by forces out of your control. The blues are a cross to bear, a prison cell, a mark on your good name, they are the bad news, it fucking hurts plenty and you really don't want to be there. When listening to the early blues masters you enter an atmosphere of gloom and abject despair, a world weariness that evokes that inescapable darkness that will visit all of us; our shared humanity through loss, shame, degradation, and endless tribulation. These musicians were chroniclers of a mood that is as old as human life itself and is ignored only at our peril, as it teaches us empathy; something you will need in return when the blues come to visit. Sinclair searches for those geniuses that helped put those emotions to music and song and subsequently created a characteristic set of artistic aesthetics and poetic and musical motifs that have saved Amerika from perpetual kultural mediocrity, bad music and being judged eternally superficial.

Fuck you, Mr Eliot!

19

75 Klicks above the Do Lung Bridge.

by Stefan Jaworzyn

One evening of channel hopping, downwards from the Sky infomercial on 999 to 40+ READERS WIVES and deeper still.

WE ALL have regrets, don't we? You don't? Really? In that case you're an egomaniacal sociopath who thinks the world is going to fall at your feet any second or a teenage douche — either way, you need to take enough powerful psychotropic drugs to alter your unhinged perspective on the way things work around here.

Right now my main regret is that I didn't have a tape running when that old carrion crow Anne Robinson used the phrase "cock lozenge" in her horrible quiz show. ('They' have tried to convince me I imagined it. What jesters.) Oh, and the fact that I passed out on the sofa one night over Easter and emerged from my coma to discover the Sky box had frozen, then commenced to channel hop downwards from the infomercial on 999 after I'd re-booted the thing, where lo, I beheld all manner of low-grade smut which had previously escaped my attention.

A peculiar load of smut it is too, with lo-fi techno thudding over bored tarts on mattresses 'chatting' on the blower, apparently to people like me. And what's special about these lovelies is their intimacy with the punter. They wink, they beckon, they blow kisses. They want only you. Occasionally they pick up a

microphone and inform you that they're available just for you, while recorded messages remind you of that fact while simultaneously putting you at ease by stating that you don't even need to talk to the cupcake in question if you're shy, you can just listen in on her intimate conversation. That sounds like value for money! I did discover one raven-haired temptress I wanted to marry on *Sportxxxbabes* but the overwhelming aura of despair and desperation emanating from the collected channels was similar to being trapped in a doctor's waiting room for mentally defective nymphomaniacs...

40+ Readers Wives features an enchantress of advanced years reclining topless on a sofa having a cheery conversation, probably with her daughter. "Auntie Gladys said what? She didn't! Well, the last time I saw her her haemorrhoids had prolapsed and she had to stuff them into a pull-along trolley just to go down the market! Did you remember the extra black pudding for the weekend? And Dad says not to be snogging Deshayne in front of him all the time, it's uncouth. I know dear, I know, but miscegenation gets him all flustered." Et cetera et cetera, world without end...

Happy Hour Girls is possibly the nadir, a line-up of five young(ish) women, wiggling, wobbling and gyrating in the most unpleasantly unprovocative manner. Now this wiggling and wobbling is something I've not previously encountered. There's bouncing and jiggling too. Why do they do it? Who told them that bouncing was a sex movement? That hopping and bopping like an epileptic with Obsessive Compulsive Disorder was arousing? And all the while faking phone sex as the techno thumps thumps thumps ever, endlessly on. Is there a sleazy chav behind the camera urging them, goading them, impelling them like mutton into the curry pot? Is there anyone behind the camera or do the pikeys just set them up and wander off to the all-night Alabama Fried Rat? Where does this insanity take place? Is the old 40+ Readers Wife just working from home while her husband does nights? So many questions.

Anyway, it transpires that one of these Happy Hour Girls, #3 to be precise, a blonde boiler with a pot belly, wears two pairs of knickers and has a long, strange straight dark line, rather like Groucho's moustache, just below her belly button. While bouncing she pulls down the first pair of panties to

reveal a thong which she then tweaks and wrenches around for some 'sensual' self-massage, like a monkey idly scratching its genitals out of boredom in front of spastic children in the zoo. Worryingly, she appeared to have a blank space between her legs. This was just wrong. Wrong wrong wrong. Perhaps it's just as well — if my daughter made a living jiggling and wobbling and telling phone perverts to fuck her in the arse for twelve hours at a time on satellite TV, I'd rather her genitals were erased. (Is £1.50 a minute a good rate to gherk off to a woman with no genitalia? I suppose it might be a better deal than calling the Sky helpline.)

One of the channels briefly failed to turn the mic off the gyrating 'babe' and the squawking harridan's torrents of obscenity would have made a post-match Millwall firm blanche. Unbelievable. Still, practice makes perfect, love. Keep up the good work.

Meanwhile back at 40+, granny is in hysterics! She unselfconsciously straightens her stockings and messes with her underwear, nibbles her finger-nails and gesticulates madly while continuing to natter, obviously completely enthralled by the details on Auntie Gladys' colonoscopy. What do sex granny's relatives think? It's just a job, innit, catch you later, yeah. My wife-to-be has deserted *Sportxxxbabes*, replaced by a beastly short-haired blonde who constantly takes her breasts in her hands and VIOLENTLY palpates them like some sort of — well, I don't know what, because outside of a Bedlam-style asylum for the sexually insane I can't imagine such behaviour exists... She pulls her face into ugly, contorted expressions, sucks her fingers, attacks her breasts again. She has nasty tattoos, probably from some pervert's mafia who plan to take over the world by rendering all males impotent via nightmarish sexual dementia.

Over on *Real Wives* there's a real wife who's not on the phone. She's fat and not very attractive. She sits on her sofa messing with her bra straps, staring at the camera, smiling in a slightly embarrassed manner. (Her bra appears to be strained to bursting point in a feeble attempt to contain her gigantic breasts.) She haplessly picks up the phone and pretends to talk, gets her boobs out and lies on the sofa, one flabby leg in the air, smacking herself on the ass. Elevator muzak plays. She manages to jiggle both breasts with one hand, or rather arm,

as she's more than just a single handful of woman. She turns and gyrates, causing avalanches of cellulite. That's one hell of a real wife.

Blue Kiss has a reasonably sexy Asian-looking girl who claims to be a porn star called Lyka Lopez. If she lived near you you'd probably fall down a manhole gawping as you stalked her along the High Street. But watching her on *Blue Kiss* is as big a turn-on as a night at the BNP's over-seventies gay swinger club.

Bang Babes 2 has a trashy blonde (in a wig, I believe) wiggling round a pole with her knickers pulled down a bit. She has some writing tattooed above her ass. Why do people have writing tattooed on them, especially where they can't read it themselves? You ain't young forever, pussycat. In the not-so-distant future you'll be a middle-aged lardass and those words of wisdom will be illegible gibberish, half-submerged amongst rolls of blubber. (But hey, if fat bastards can claim they're suffering from an 'epidemic' of obesity, then why can't dumb fucks make their excuses as victims of the Great Stupidity Plague of the Twenty First Century?)

Meanwhile it's 'No Bra Time with the Happy Hour Girls' though they are not aware of it; at least not the three unattractive ones who are kept separate from the two hotties; or perhaps they simply chose to flout the rules, a small victory for personal freedom in a world of repressive smut. Oh, jolly good, the bird I want to marry has moved to *Livexxxbabes*, while the ghastly *Sportxxxbabes* blonde incubus is in the midst of another apoplectic arse-wobbling frenzy. But wait! After a quick check on sex granny and the porcine brute from Channel Satan, she's vacated *Livexxxbabes* (I took down her number first), replaced by a horse-faced ass-slapping skank in big black glasses who resembles a slightly younger version of the [*word illegible*] in the first Electric Six video. Yeah, that one.

Agnes (for that is how she shall henceforth be known) really can't keep still. It's curious to conjecture that there may be a whole new generation of women for whom a post-feminist reclaiming of their sexuality appears to equal a kind of St Vitus Lap Dance which not long ago they'd be burned at the stake for perpetrating. Now I'm the last person to maintain a woman should be persecuted for wobbling lasciviously, but this is — oh, fuck it, what does it matter...

Man, that Agnes is really walloping the hell out of her ass. Sit down, woman: shoot some smack, have a cup of herbal tea. But no, she shakes herself, slaps herself, wobbles and bounces. Now she's molesting her boobs, jouncing them, kneading them, tweaking her nipples. What in the name of all that's holy is wrong with her? She lifts her legs in the air, clamps her arms round them and jiggles like starving Africa depends on it. She formulates terrifying facial expressions, contorting her lips into a rictus snarl that's several light years away from enticing. Perhaps she's experiencing an extended psychotic episode, reliving past psychic injuries so intense as to be inconceivable to a booze-sodden sot on a sofa. But my, Agnes, what ferocious choppers you possess. There is no part of me I would ever willingly conjoin with anything containing such masticators.

Now she's feverishly oscillating her breasts from side to side. (She has some weird marks above her panties that look like three flies crawling up her belly.) Now she's reclining, horse face grimacing, her countenance increasingly twisted and disturbing. Now she's fellating her fingers. What a seductress. What a spectacle. Where does it end?

The blonde abomination on *Sportxxxbabes* has her legs up almost behind her head, still managing to bounce her ass up and down, up and down like an infinitely repeating tape-loop of demonic arousal (The Devils of Loudon got nothing on her), while the monstrosity that is Agnes is poking her tongue out in a gesture similar to Jack Nicholson's when he says "poontang" in whatever that film was...I can't stop thinking about the "Danger! High Voltage" woman and wondering how the blasphemous cretinism displayed on these channels is connected to sex. Good god, now she's pulled her hair back and she looks like Joyce Grenfell! She puts on some lipstick and idly pinches her nipples as she picks up the phone...

[*Mr Jaworzyn failed to supply an acceptable conclusion to this piece, the 'research' for which resulted in both divorce and sexual harassment proceedings. After repeated requests to re-write the final paragraphs were refused we were obliged to remove them for legal reasons.*]

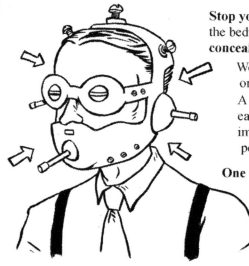

||

Mardi Gras 2008
Go get your Big Chief.

by John Sinclair

When DAVID KEREKES and CALEB SELAH of Headpress came to Amsterdam in January to talk about the next issue, I was getting ready to leave for New Orleans to perform my ritual duties with the Wild Magnolias and the Mardi Gras Indian Nation, as I've been doing since 1976 (and haven't missed since 1981). They asked for a report, and here it is.

THERE'S A lot of Africa in New Orleans. It came here on slave ships directly from the western Atlantic coast, and then in a huge wave 200 years ago when some 10,000 Haitian émigrés inundated New Orleans and doubled instantly its previous population. And the ancestral spirit lives on in the music and culture created by successive generations of African Americans in the streets and neighborhoods of the Crescent City, where the West African vibe ever pulsates just below the surface of everyday life and erupts out into the open whenever it wants to.

There's plenty of Africa in the air on Mardi Gras in New Orleans, the day when the ancient spirits infuse the city's most battered neighborhoods and lift their inhabitants to a higher level than simple survival through an ever-renewing public ritual based in ancestral forms and rhythms and dances. The

native spirits and the brave warriors of the land of their captivity are honored
and celebrated in equal measure as well, beautifully represented by black men,
women and children elaborately dressed in brilliant hand-tailored ensembles
constructed of plumes, rhinestones and intricate beadwork inspired by and
modeled after the ceremonial and war outfits worn by the Plains Indians of the
eighteenth and nineteenth centuries.

You can see the Mardi Gras Indians in backstreet neighborhoods all over
New Orleans on Carnival Day, dancing and chanting their Wild Indian songs
propelled by their surging second-lines all the way from Eagle & Pine, 2nd &
Dryades, Washington & LaSalle down to Claiborne & Orleans in the Treme
where all the downtown Indians meet up and get together before the day
is over: the Yellow Pocahontas, the White Cloud Hunters, Spirit of Fi Yi Yi,
Guardians of the Flame, Congo Nation, the White Eagles, the 9th Ward War-
riors, the Seminoles, the Apache Hunters and fellow tribes from the 6th, 7th, 8th
& 9th Wards.

In the olden days, the uptown Indians would swagger downtown with their
gangs — the fabled Creole Wild West, Big Chief Jolly & the Wild Tchoupitoulas,
the Golden Star Hunters, Big Chief Pete & the mighty Black Eagles, the Young
Geronimos, Big Chief Monk Boudreaux & the Golden Eagles, the Wild Magno-
lias and Big Chief Peppy & the Golden Arrows — to confront their counterparts
and have some extra fun "playing Indian" for a day.

Even into the 1980s, there was one year when I had the thrill of march-
ing in the second line behind Big Chief Bo Dollis & the Wild Magnolias from
2nd & Dryades over to Jackson & Claiborne and then up the expressway ramp
and down the I-10 all the way to the French Quarter exit and Orleans Avenue
to meet some downtown gangs. But now — twenty five years down the road
— they don't do that any more, and, even worse, this year Big Chief Bo Dollis
has sadly been physically diminished by a stroke and had to ride through the
streets of the 3rd Ward on a little motor scooter with his Big Chief outfit on.

The city itself has been seriously diminished by the crippling impact of the
Great Flood of 2005, a natural disaster of Biblical proportions that's been com-
pounded beyond measure by the ugliest sort of political chicanery and white

supremacist social policies designed to deliver the New Orleans of the future to the white people and prevent the poor black populace from ever returning to this place which after all was built on the backs of their forebears and housed their families for generations.

They don't want them back. Some white people have been heard to say that God has answered their prayers to get rid of the Americans they brought over from Africa so long ago and now it's up to decent citizens and their civic leadership to keep them from returning

Three things first:

[1] They won't restore and reopen Charity Hospital.

[2] They're tearing down the public housing projects and destroying more than 5,000 apartments once filled with poor black families who wish to return from their wretched lives as refugees.

[3] The government and insurance company money for storm recovery goes to people who owned their homes. Renters, who made up half the population before the Flood, receive nothing to offset their losses and vast tracts of former rental housing still wobble ruined and vacant where thousands of black families once made their homes

They don't want them back, and they're redesigning the city to make it safe for white people with an income and impossible for poor people to penetrate. Rental housing is hard to find at twice the pre-Flood rates and the cost of living has swelled out of proportion. The public schools have virtually been jettisoned in favor of a semi-private "charter" system and public health services are few and hard to find and remain severely out of reach of the poor and unemployed.

A couple of quick statistics:

[1] Before the Flood New Orleans had shrunk from 600,000 to 450,000 inhabitants. That was about 150,000 white people who fled the urban environment in the 1960s and seventies and eighties and nineties to resettle in Jefferson Parish, the West Bank and Across the Lake. Now they say the city is back to 300,000 residents. That would make about 150,000 black people who have been refused the opportunity to come home and try to replant their roots and take up their lives again.

[2] The New Orleans City Council has a white majority again. Mayor Ray Nagin (or Nay Reagan as some call him) is a handmaiden of the local bankers and real estate developers and a criminally incompetent public servant who won re-election after the Flood against a field of twenty one candidates of the Caucasian persuasion. His political rival and former City Council president Oliver "Uncle" Thomas, who had applauded the decision to raze public housing by proclaiming that the government was done with supporting the lifestyles of people who wouldn't work and just laid around in the projects all day, is now in prison following his conviction for accepting bribes.

[3] Everyone in New Orleans suffered heavy emotional damage and traumatic stress from the effects of the Flood and the ruination of their homes and lives. Thousands of people must be in considerable mental distress and seeking some kind of solace or counseling services, but there's nothing for it. Public psychiatric care is basically missing in action and the city is able to offer less than 100 beds for patients in serious mental trouble.

This is some sick shit, especially because — even despite the crippling effects of natural disaster and leadership failure — New Orleans remains the final urban cultural wetland still breathing new life and blossoming new flowers of art and idiomatic expression into the suburban ruins of our shrunken civilization. Even amidst the wreckage the spectacular African American culture of New Orleans continues to draw from its roots and bloom with contemporary spontaneity, making music and art and dancing in the streets as a way of life.

But the cultural products created here by indigenous composers, musicians, writers, poets, painters and other resident artists are manipulated by the hucksters of commerce and tourism to project a tantalizing image of care free fun and frolic in a sort of seedy Disneyland tailored to the dreary fantasies of white people from all the suburbs of America, while the creators as a lot are largely unrewarded and left to scuffle for simple survival as human beings and family members.

The thing is that they are creating art as a function of daily life — that's what they do, that's what they've always done — and projecting it back into the environment that gave it life to illuminate the lives and imaginations of their fellow citizens in the beat-up backstreet neighborhoods of the Crescent City where any opportunities for fiscal accumulation are fully lacking but you can have the best time of your public life at the second line parade through your neighborhood this Sunday afternoon.

In New Orleans music is still part of everyday life. Musicians get together and play and form bands because they like each other and the way each other sounds. The players most deeply steeped in the tradition can play anything with notes in it, swing it the way it's supposed to be swung and sing it the way it's supposed to be sung.

The music of New Orleans is about life and exuberance and cultural expression and making people dance and moving them down the middle of the backstreets jumping and leaping and throwing their hands in the air like they just don't care while the sun beats down and the Rebirth Brass Band pounds some serious musical ass all afternoon long. It's about playing the blues in some nasty little streetcorner taproom or putting the music out there for the swinging white people at Tipitina's and the Maple Leaf Bar and the House of so-called Blues.

Music is part of life and life is all up in the music. That's the way it's supposed to be, and that's the way it is in New Orleans even today, two and a half years after the Flood and with acres of devastation still fanning out from the revived French Quarter and the restored neighborhoods along the river. (It's hard to imagine, but it wasn't the river that flooded — the water came all the

way from Lake Pontchartrain when the levees broke and submerged eighty per cent of the city, sparing only the few blocks between Rampart and the river and St Charles and the river from the effects of the Flood.)

The music is alive and it's leading the city back to life — the joyful life of the backstreets and barrooms where the music comes from, and where it is always determined to return. At the Mardi Gras the city is fully alive with the spirit of music and celebration in the streets and even the white people have the time of their lives exercising their rusty imaginations and acting out the perennial public rituals of Carnival Time amid the spectacular parades staged for a million people to enjoy at a time.

The Mardi Gras they show on television, with wall to wall people mindlessly churning and lurching along Bourbon Street, has nothing whatsoever to do with the real thing. The real thing takes place outside the French Quarter and is centered on the gigantic public entertainments presented by the upper classes for the broad masses of the people, as we used to say. Huge, elaborately decorated theme floats towed by tractors and stuffed with people in matching costumes throwing beads and branded trinkets to the clamoring throngs proceed down St Charles Avenue from Napoleon to the uptown edge of the French Quarter and then on to the old Municipal Auditorium by Rampart and Basin Streets where they disband after several hours of torturous progress through the teeming streets.

Along with the public spectacle that frames the season for the entire city, the real thing is a family affair for people of every social stratum and it happens in their neighborhoods with the members of their extended families, friends and fellow residents and all their myriad children. White people, black people and every sort of people inbetween take a big part in the carnival season and fully exploit the opportunity to come together in a rare instance of hopeful unified social focus and have as much fun as they possibly can without hurting anyone in the process.

This is why I love to go to the Mardi Gras, and why I moved to New Orleans in 1991 to live for the next twelve years in the heart of the city and participate fully in its wildly disparate cultural lifeways. I first went to New Orleans in

1976 to find the Wild Magnolias and discovered a fantastic cultural wetlands far beyond my wildest dreams. My friend and mentor Mac Rebennack, aka Dr John, had tried to prepare me to behold the musical and cultural riches of the Crescent City, but the reality went way past any possible description and blew my mind to smithereens.

I went back in 1977, then missed several years until I went to my first Jazz-Fest in 1981 and kicked myself in the ass for passing up the chance to be a part of the Mardi Gras every year. I've made every one since 1982, whether I was living in Detroit, New Orleans, or Amsterdam, and I pray to return for Carnival each and every year as long as I live.

John Sinclair is the author of *It's All Good: The John Sinclair Reader* (published March 2009 by Headpress)

Mardi Gras 2008
Eye-Witness Report

by John Sinclair

THURSDAY 24 JANUARY

MARDI GRAS this year started for me with a flight from Amsterdam via George Bush Intercontinental Airport in Houston to Louis Armstrong International Airport and a ride into town with my beloved daughter Celia and her hostess and sponsor since her return to New Orleans last fall, the former Polly Palfi.

Celia, a resident of the Crescent City since she matriculated at Loyola University in the fall of 1987, suffered massive emotional trauma in the aftermath of the Flood and had to flee to Detroit to try to pull herself back together. When I was in Michigan last October preparing to go down to New Orleans to screen my movie Twenty To Life at Tipitina's, Celia confided that she was ready to go back home and asked me if I would take her there with me, so I rented a car and we drove down from Detroit together.

Now ensconced in Polly's mid city home and working in a used bookstore while preparing to resume her normal activities as a computer graphics specialist and designer of CD packages, books and posters, Celia decided to take a prolonged leave of absence from her job so she could spend the next two or three weeks with her father, and from the moment I arrived in New Orleans she would be my faithful driver, daily caretaker and constant companion, making me an incredibly happy man.

I would be domiciled at the splendid Elysian Fields residence of Tom Morgan & Hild Creed who would regale me with their unstinting hospitality — and access to Tom's magnificent record collection — until the Friday after Mardi Gras, when I would move on north and east to the hill country of Mississippi and spend a couple of weeks in residence with my friends at the Two Stick sushi emporium and music bar in Oxford, the Literary Center of the South. I had met Tom at JazzFest in the nineties, visited with him and Hild in Charlottesville VA, applauded their move to New Orleans and beamed with pride as Tom took his place in the city's musical community as an important program host, producer and "live" broadcast anchor at WWOZ-FM, where he now also serves as the station's webmaster and a key fund drive organizer.

SUNDAY 27 JANUARY

THE SERIOUS fun started Sunday evening when we headed uptown for Unified Indian Practice at Handa Wanda's, the funky nightspot by 2nd & Dryades that's replaced the H&R Bar as the headquarters of Big Chief Bo Dollis & the Wild Magnolias since the H&R burned down a few years back. There's a Creole Wild West practice down the street in this rough Central City neighborhood where Buddy Bolden used to live, and the Wild Magnolias have invited Big Chief Roddy & the Black Eagles to co-host the affair at Handa Wanda's.

"Indian practice" is just what it sounds like: Wild Indian tribe members and their followers getting together to practice the Mardi Gras Indian songs and chants and dance steps and the choreography required for the ritual meeting of one Indian gang with another in the ghetto streets on Carnival Day. The Big Chiefs and their back-up lead singers work out their stories and practice their deliveries, and the second-line respondents learn which refrains go with which songs and when they are meant to change. There's fierce Wild Indian dancing and a big corps of street level percussionists pounding out the hypnotic beats on everything from bass drums and tom-toms to congas, cowbells and beat-up tambourines.

Big Chief Bo Dollis still reigns over the Wild Magnolias with his wife Rita as Pretty Big Queen but his diminished physical state keeps him off the mic and his son Gerard has stepped up to lead the Indian practices and head up the Wild Magnolias in the streets. Little Bo has joined forces with Big Chief Roddy of the mighty Black Eagles from the now-shuttered Calliope projects to organize this year's Unified Indian Practices at the Handa Wanda every Sunday evening, and they're drawing a hell of a crowd.

I've been making the Wild Magnolias Indian practices and following the Big Chief through the streets on Mardi Gras Day since 1976, and I've made a lot of friends among the tribe members and their second line whom I continue to meet and greet today — guys like Crip on the tambourine and Norwood "Geechie" Johnson on the bass drum who played on the first Wild Magnolias album in 1973, Big Queen Rita and Chief Little Bo (I remember when he was born), Big Chief Monk Boudreaux of the Golden Eagles and his brother Larry and another brother they call Yeti who's one of the finest singers of Wild Indian songs ever to be heard. I've rolled with Big Chief Roddy as well as with his father, the late Big Chief Pete, and I've eaten a ton of hot tamales prepared by a cat named Floyd, former Big Chief of the food wagon nation, and marched for miles alongside his brother while we beat on tambourines and chanted the refrains to the Big Chief's songs.

So it's really great to be back at ground zero at Carnival Time. I might be anywhere in the western world at any given time, but — to paraphrase Zippy the Pinhead — mentally I'm here with the Wild Magnolias at 2nd & Dryades in the 3rd Ward of Central City New Orleans, encompassed by the warmth and joyful exuberance of these resilient down-trodden citizens who are pitifully short of funds but rich in imagination, creativity, compassion and love of life.

Unified Indian Practice isn't really a new idea, but the title is a new and hopeful sign of these perilous times when the city is being reshaped in the image of the racist white power structure and the people on the underside have to band together more than ever before to struggle for the survival of their neighborhoods, their cultural imperatives, their brilliantly improvised and persistently resistant way of life that has seen them through worse times than these

and must continue to sustain them in their painfully prolonged recovery from the physical, economic and emotional devastation wreaked by the forces of nature and the failure of the US government to provide sufficient funding for an effective flood-control system to protect the city from heavy weather.

Unity is good; to proclaim unity is even better; and to achieve unity, to live and struggle in unity with others is indeed superb. We need as much unity among people who share our own social circumstances as we can possibly manage, and we need it now more than ever. Amen. I guess that's why I was excited to see the name Unified Indian Practice and hope it will remain in use. The Mardi Gras Indians and the cultural matrix they represent are under serious attack by the alien force called America and they do not inhabit the top of the charts in terms of the kinds of things that the white people wish to preserve in their glossy projection of the future.

There was a lot of unity at Indian practice this year, an extremely high level of spirit and emotion, and some things I hadn't seen before like the fierce ritualistic dancing of several women warriors at once and the spacious stage at the back of the room that was packed with at least a dozen flailing percussions of every persuasion. A functioning sound system let the voices of the singers be heard throughout the room and got the whole crowd involved in chanting the correct refrains, from the traditional "Two Way Pak E Way" and "Shallow Water O Mama" to current responses like "Two More Days" and "Go Get Your Big Chief," struck up when a downtown Indian gang burst through the doors of the club and proposed a showdown on the floor led by their Spy Boy, Flag Boy and Wild Man. "Go Get Your Big Chief," the crowd yelled back in derision, and a terrific ritual encounter was under way.

A voluntary recording krewe from WWOZ under the direction of the great Khalid Hafiz was in the house to capture some of the proceedings for later airing, and this inspired me to whip out my little Olympus 320M digital recorder and push the record button and hold it up at head level to pick up some of the action. I got some powerful singing by Big Chief Roddy, quite a bit of Little Bo and some of the assorted Indian singers who took over the mic from time to time.

ASH WEDNESDAY 6 FEBRUARY

BIG FRITZ was a real New Orleans character of the Treme, America's oldest urban African American neighborhood where the music we know as jazz came to be and flourish and lives on in the music played in the streets and corner bars in the twenty first century — the music of the Treme Brass Band, the Dirty Dozen, Rebirth, the Li'l Rascals Brass Band, the New Birth, the Soul Rebels, the 6th Ward All Stars, Trombone Shorty & Orleans Avenue, Kermit Ruffins & the Barbeque Swingers, Shannon Powell, John Boutte, Kirk Joseph's Backyard Groove.

In the 1990s Big Fritz and his sister Lois (Loyce) Andrews ran the Trombone Shorty club named for her youngest son Troy at the corner of St Philips & N Robertson, the site of the old Caledonia Club and the one public place that's felt like the home I live in mentally wherever I am. My friend and mentor Jerry Brock took me to Trombone Shorty's one evening in 1992 and introduced me to the people he called his real family in New Orleans: Big Fritz, Loyce, her husband "12," their son James the young trumpet sensation, 12's brother Aldo, and the other characters who kept the place open and the music playing and the good feeling happening at all times.

Big Fritz was also a key member of the Treme SA & PC known as the Money Wasters whose annual parades through the 6th Ward were the stuff of legend, he was an accomplished chef who would cook up huge pots of gumbo and turkey necks on the sidewalk outside the club and dish them out to the patrons compliments of the house, and he was also the guy who had the dime bags of pot on hand for serving the countless vipers in the house. Fritz sort of took over the neighborhood weed concession when an old timer they called Uncle Ratty passed away.

Big Fritz had been incapacitated for the past few years and was living in a managed care facility when he died, but his family, friends and fellow club members saw to it that he was put away in style the traditional way with a jazz funeral and a second-line procession through the neighborhood that would stop in front of significant personal landmarks of the deceased and toast them

with Fritz one last time. The band was assembled by Fritz's nephew Glenn David Andrews from the plethora of 6th Ward players who had been part of the big man's life and they led the parade with high spirits and bright memories of the dearly departed.

I turned on my recorder and caught the strains of the band as they blew it out under the I-10 overpass at Claiborne & St Philips, serenaded the funeral home where Big Fritz's body had lain in rest with a soulful reading of What A Friend We Have In Jesus, and finished up with a boisterous number directed at the front portal of Fritz's former residence while some of the brothers banged on the door and shouted his name.

In the 6th Ward that's what's known as "having a happy death," and it helps take the sting out of the sudden loss of a loved one like nothing else. The day ended with the regular Wednesday night performance by the Treme Brass Band at the Candlelight Lounge where the neighborhood regulars danced the evening away with friends and strangers alike.

FRIDAY 8 FEBRUARY

WHEN I'D arrived in New Orleans two weeks ago the first phone call I got was from Jerry Brock, my closest and one of my oldest friends in town, and I'd been looking for him ever since with no success. He wasn't at the Backstreet Museum, he wasn't at the Trombone Shorty show at Tipitina's, he wasn't even at Big Fritz's funeral parade, and I felt bad thinking I was going to have to leave town without having seen my boy.

Then Jerry called again after I got back to Tom & Hild's on Thursday night and made a date for breakfast the next morning before Celia and I would drive up to Mississippi to begin my two week residency at the Two Stick in Oxford. Celia had offered to carry me to Oxford and bring the rental car back to New Orleans, and I talked her into staying with me for a few days and meet my people up there.

For two weeks Celia had been driving me around to a series of medical appointments set up for me by the Musicians Clinic to take care of everything that

was or might be wrong with me in my old age. Friday morning we had to stop by Napoleon & Claiborne to see the foot doctor one last time and check on the progress of the healing of an infected toe that had been bothering me since its eruption in Italy last September. That put us a little behind schedule for breakfast with Brock, and after a series of exploratory phone calls we determined to meet up at the bakery spot at the corner of Chartres & Spain in the Marigny as soon as Celia and I could get there from uptown.

I met Jerry Brock around 1981 at an art studio he shared with the photographer Michael P Smith and a character called Mischa on Race Street near the river where I'd gone to find a copy of Spirit World, Michael's ground breaking work on the Mardi Gras Indians and the Spiritualist Churches of New Orleans. I recognized him from the streets around 2nd & Dryades when the Wild Magnolias came out on Mardi Gras and Jerry Brock, Michael Smith and Nancy Ochsenschlager — my old pal from Ann Arbor who first brought me to see the Big Chief and who's now the recently retired director of the Louisiana Heritage Fair — were the only three white people in the crowd.

We hung out together a couple of times at Mardi Gras and JazzFest the next year and I met his brother Walter, who'd immigrated to New Orleans from Dallas with Jerry and their express intention to establish a community radio station that would play New Orleans music and related jazz and blues material in New Orleans on a daily basis. They burst onto the air in December 1980 as WWOZ-FM, 90.7 on your dial, broadcasting from studios on the second floor of Tipitina's and a primitive transmission tower on the bank of the Mississippi River. Jerry instituted the programming mix that largely persists to this day and created a powerful presence in the community based on serving the music and the musicians and keeping the tradition alive for everyone who had a radio.

Jerry and Walter left the station in the late eighties after engineering its transfer to the New Orleans Jazz & Heritage Foundation, the current owners. Jerry had produced the first album by the Rebirth Brass Band for Arhoolie Records and was writing and doing engineering and production work around town while readying his next project, a French Quarter record shop operated with his partner Barry Smith that would aim to stock every record by every Louisiana artist in

every musical category, plus the finest selection of jazz and blues recordings one could ask for. The Louisiana Music Factory would also install a small stage and house sound system to encourage "live" performances by local musicians.

The Music Factory opened for business on N Peters in early 1992, just after I'd started broadcasting my first show, Blues & Roots, on WWOZ, and was an instant success, setting a new standard for comprehensive service to musicians and music lovers alike. After several years at the helm Jerry sold his interest to his partner to concentrate on making records, films and books of his own devise. He produced the classic Treme Brass Band album, Gimme My Money Back, for Arhoolie Records and co-produced the historic meeting of Doc Cheatham & Nicholas Payton for Verve. He collaborated with Royce Osborn on a film on the black Mardi Gras traditions that knocks one's eyes and ears out, and he's still working on his essential history of New Orleans music and its roots in the geography, economy and culture of the days of French ownership and rule.

Jerry Brock is as real as they come, and I'm proud to call him my friend. It was great to see him and get to talk with him at our sidewalk breakfast table before leaving town, and I just wish I could've taken him with me. Like so many people in this incredible town, he's the kind of human being I love to spend my time with, and I'll be back next year — god willing — to hook up with my family of friends when Mardi Gras rolls around again.

NOTE My street recordings from Mardi Gras 2008 (the Unified Second Line, the Zulu Parade, the Indians in the streets, Ernest Skipper & Fi Yi Yi in front of the Backstreet Cultural Museum, and the 6th Ward All Star Brass band at Big Fritz's funeral parade) have been edited into a one-hour episode of my radio show and posted at RadioFreeAmsterdam.com as John Sinclair Radio Show № 194.

A review of Charlie White's book Monsters.

by David Kerekes

I WAS on the 67 bus looking at the book MONSTERS by CHARLIE WHITE. I enjoy these photographs (they look like key scenes from nonexistent movies), but there is a crossover between this book and an earlier one of his I'd already reviewed in Headpress. Rather than another review I decided instead to ask my fellow passengers what they thought of Charlie White.

LADY WITH A BONNET [*looking at photo and misinterpreting it entirely*]: A shoulder with eight limbs and a boy joined at the head...

ME: I want to get back to the nature of art on this for a moment. Do you not like this? A man carrying a severed head?

LADY WITH A BONNET: It's just... trash.

DRUNKEN SCOTSMAN: It's like Damien Hirst! It's trying to be shocking.

ME [*turning to series of photos featuring an alien creature*]: What about this?

DRUNKEN SCOTSMAN: That's slightly cleverer, but it's still blatantly trying to be edgy and out there.

LADY WITH A BONNET: It's too obvious.

ME: This creature looks quite real.

LADY WITH A BONNET: What do you mean?

ME: Real.

LADY WITH A BONNET: I doubt it.

ME [*turning to portrait of a young girl*]: There doesn't appear to be anything untoward going on in this one.

LADY WITH A BONNET: Exactly.

ME [*turning back to man carrying a severed head*]: This severed head. I'm surprised you don't like that one.

Not all the people on the number 67 bus like Charlie White like I do.

MONSTERS
Photographs by Charlie White
£25 hbk ISBN 9781576873694 powerHouse
2007 Distributed in UK by Turnaround

|||

Mozic and the Revolution Revisited.

by Rich Deakin

Britain's COMMUNITY BANDS of the late 1960s and early 1970s.

MUSIC IS a soundtrack to popular culture. The revolutionary movement of the 1960s was no exception. 1967 is forever associated with flower power, peace, and the summer of love, while 1968 —tumultuous in terms of global unrest and revolutionary ferment — is synonymous with being "the year of the barricades." Much has been written about 1968 and music and revolution, most notably Mick Jagger and John Lennon in Britain and their brief flirtations with radical chic. However, there was also a music scene operating at a grass roots, street level of the British counterculture that included the likes of the Deviants, Edgar Broughton Band, and slightly later Pink Fairies, Hawkwind and Third World War.

These bands did not have the same clout as first division rock stars, like Jagger and Lennon, but no one in Britain did more to promote music as a revolutionary medium than Mick Farren, front man of the Deviants and regular columnist for the underground press. Frequently finding himself and his band on the receiving end of police "stop and search" tactics, Farren was often moved to make anti-police diatribes. In an article for International *Times (IT)* (Jun 68) entitled "Guerilla Pop," he talked of providing "a turned-on army,

music instead of bullets, happenings instead of battles," adding "A rock group on a rooftop can be as effective as a machine gun... Putting pop groups into the streets, into parks throughout this summer is the first move."

By the time the Rolling Stones released Street Fighting Man in August 1968, Farren and the Deviants had already rewritten the music industry's rulebook by making a record and releasing it themselves, thereby keeping the means of production and distribution within the underground. They played a number of benefits in support of various radical causes throughout the year, including a student sit-in at Essex University and anti-Vietnam war festival in Trafalgar Square, where their homemade pyrotechnics very nearly put paid to the band as well as a section of the audience.

FROM THE Midlands town of Warwick, the Edgar Broughton Band was spearheading the assault from the provinces. Moving to Ladbroke Grove in October 1968, the Broughtons quickly nailed their revolutionary credentials to the mast, announcing a preference for free concerts with an intention to perform as many as possible over the coming year. They often instigated collections at their gigs "for those living destitute in London's parks," and after the free Hyde Park concert in September 1969 presented approximately £100 to the occupants of the infamous squat at 144 Piccadilly.

That same month the Edgar Broughton Band and a cohort of Hell's Angels visited Warwick in defiance of the town council's ban on a free concert. Echoing Mick Farren's exhortation about "putting pop groups into the streets and parks," they played on the back of a flatbed truck to a crowd of more than 200, which they lead, pied-piper like, through the streets causing much disruption in the process. Afterwards Edgar Broughton was quoted as saying: "I don't think I could possibly lead a revolution in the physical sense... The revolution must come from the people themselves." He added: "We don't go out to incite riots, of course, but if there's any trouble when we play then that's just hard luck."

Farren seems to have found a kindred spirit in Edgar Broughton, and by the summer of 1969 the Deviants and Edgar Broughton Band regularly shared

the same bill. It even seemed the Deviants were on the verge of some kind of wider acceptability. But the usually indefatigable Farren was showing signs of disillusionment with the politics of the underground rock scene. He told *ZigZag* (Sep 69): "We used to be heavily political, but the validity of that sort of statement coming from a rock'n'roll band is becoming somewhat questionable... it's OK if you are in a band which is very closely allied to the community, but the community has become so diverse that it's impossible for a group to be that much a part of it."

If Mick's radical affectations appeared to be waning, he wouldn't be allowed to forget them in a hurry. Germaine Greer, in an *Oz* article called "Mozic and the Revolution" (Oct 69), bemoaned the credibility of the wider underground music scene transmitting revolutionary ideals, with particular reference to the futility of Mick's own efforts. This she blamed on Mick's inability to hear what rock music was really about, in turn suggesting he didn't really understand his target audience, nor they him, "They wanted to have a good time," wrote Greer, "and there was this wheezing Jeremiah begging them to hate something. They were too good mannered even to hate him. Mick ended up hating nearly all his audiences. He meant to yell at their parents, but he ended up yelling at them."

Farren was ejected from the Deviants in October 1969 when the rest of the band decided to pursue a more musically competent route, having tired of his revolutionary histrionics.

TRADITIONAL RECORD companies, management and agencies were viewed with suspicion within the underground music scene — emasculating, sanitising and repackaging the original deal into something less threatening and more palatable in order to turn a profit. And therein lies the rub. Three of the leading UK underground groups of the era — Pink Fairies (into which the Deviants mutated after Farren's departure), Hawkwind and Edgar Broughton Band — were all signed to major labels. The Deviants had provided a template for independent labels several years earlier by self releasing *Ptooff!*, but it was an exception to the rule. Signing to a major label was a necessary evil in the late sixties and early seventies, and in order to become a successful propagandist one had to

deal with the music establishment on its own terms — subverting it and not be subverted by it. Asked whether signing to a subsidiary of corporate capitalist giant EMI compromised their ideals, Steve Broughton was moved to say: "If we sell as many records as they would like us to, and if we sell as many as *we* want to, eventually we are going to turn people onto burning EMI down."

Similarly, the Pink Fairies told *ZigZag* (Sep 70) in the summer of 1970, before having a record deal: "I think it's really good to rip off a record company for a huge amount of bread — I think that's really far out because they're the people you should rip off... The whole community system/underground has got to be financed and the way I see it, the record companies are in a good position to do it."

Such rhetoric didn't stop letters appearing in the underground press accusing bands like the Broughtons and the Fairies of being "fakes" and "underground hypes."

The underground press proved relevant to the likes of so called 'community bands,' such as Hawkwind, the Edgar Broughton Band and the Pink Fairies. Farren says:

The relationship with the 'community' bands was highly symbiotic. The underground press publicised them, which made it possible for them to tour and get record deals. They travelled around spreading the ethos, and the demand for the newspapers and magazines grew and flourished for a while.

It was far from a superficial relationship, as evidenced when underground papers and magazines such as *IT*, *Oz*, *Friends* and *Nasty Tales* were busted with frightening regularity. The bands would play benefit gigs, providing a means for publishers to pay legal costs and mount a defence for themselves.

Festivals became an integral part of the ethos and lifestyle of the community bands and counterculture in general. If not playing free festivals, such as Phun City or Glastonbury, Hawkwind and Pink Fairies would set up outside the perimeter fences of major festivals and provide free music to those unable

or unwilling to pay the admission price. The 1970 Isle of Wight Festival is a case in point, and both bands provided free non stop music for hours on end.

Significantly, the Isle of Wight festival was instrumental in establishing the British White Panther Party. It is well documented how gangs of foreign anarchists, English Hell's Angels, White Panthers and other agitators engaged in pitch battles with security guards and tore the fences down. The White Panthers name was initially a cloak of subterfuge used by Mick Farren to highlight the concentration camp like conditions of the festival site; he encouraged maximum disruption by publicising how the festival could be viewed free from a huge escarpment nearby. Farren may have used the name as a hit and run job to disrupt a rock festival and the capitalist proclivities of its promoters, but under the aegis of the White Panthers numerous community initiatives

arose back on the Grove. Neighbourhood councils and free food/clothing programmes were in turn supported by a number of local bands, who began to play for free under the arches of the Westway flyover at Portobello Green. These gigs and promoters, such as the Greasy Truckers, proved instrumental in founding the Westway Theatre and, later, the notorious punk and reggae venue Acklam Hall.

IN OCTOBER 1970 Mick Farren reported the formation of the British White Panther Party and its objectives in an article for *Melody Maker* (Oct 3, 70) ("Rock: Energy for Revolution"). Its aim was "to work within the freak community in Britain." Farren acknowledged the futility of attempting to replicate tactics used by American militants, because the problems of British society were different and less extreme.

Adopting the name and taking many of the ideals from the radical black militant organisation the Black Panther Party, the original White Panther Party was established in the US in 1968 by Detroit cultural revolutionary, and then manager of the MC5, John Sinclair. The legacy of the American Panthers struck a chord in the politically turbulent era of early seventies Britain. Taking their cue from Farren's White Panthers, British chapters emerged in Manchester, Glasgow, Exeter and several around London. Interviewed by Jonathon Green in 1987, Mick Farren said: "We formed the White Panther Party to do something, I don't know what... People want a name, post-hippies out of money wandering round wondering what had happened to flower power and walking around in worn-out velvet pants. Furious amounts of drugs — people were shooting heroin by then. Post-hippie junkies."

The late John Carding of the Abbey Wood chapter ("very serious cats," according to Farren), frequently espoused radical rhetoric in the pages of the underground press, and the White Panther Party's ten-point programme was itself based on the Marxist-Leninist version of the American Black Panther Party programme. Point Ten summed up:

We want a free planet. We want a free land: Free food: Free shelter: Free Clothing: Free music and free culture: Free media: Free technology: Free education: Free health care: Free bodies: Free people: Free tenant space: Everything free for everybody.

On a more realistic level they also championed environmental causes. Point Seven stated: *"We want a clean planet and a healthy people... We want to restore the ecological balance of the planet and secure the future of humanity and its environs."*

Bands frequently played benefit gigs to raise funds for the Panthers, and the Panthers were on hand to provide food and extolled the efforts of these bands in the underground press, or their own newssheets, such as *Chapter!*, *Street Sheet* and *White Trash*.

DURING A decidedly fraught tour of Germany in February 1971, the Edgar Broughton Band and their promoters were accused of overpricing by militant German audiences hell bent on making all rock music free. Eventually exonerated in Germany, the band's reputation remained somewhat tarnished in Britain when news of the tour filtered back. That summer, the Broughton's embarked on a free "guerrilla tour" of English seaside towns: Redcar, Blackpool, Brighton and Weston Super Mare. Cynics said it was an attempt by the band to regain their underground credentials following the German debacle. Whatever the reason, the tour was virtually scuppered before it began. Despite a ban in the towns they were touring, the Broughtons played regardless, on a flatbed truck, and were arrested more than once.

Local councils and police may not have been compliant but some education authorities were, and the Broughtons extended their free music programme that summer by playing a series of "Children's holiday summer play centres" at schools in London, Manchester, Bristol, Nottingham and Newcastle. Edgar told *Beat Instrumental* (Sep 71): "gigs organised by schoolkids actually come off, whereas a lot of events organised by freaks never happen."

THE ANTI-WAR movement and message of peace of love was still high on the counterculture agenda, but coming to the fore in the early 1970s were politically emotive issues like the IRA and internment in Northern Ireland, the Angry Brigade, women's lib, and gay lib.

The Angry Brigade equated to a British version of the German Red Army Faction and Italy's Brigade Rossi. Rather than indiscriminate acts of violence, their targets were symbols of capitalist society, such as property. When the Angries used the underground press as a mouthpiece, the Special Branch investigation in the aftermath of the Angry Brigade bombings impacted on the wider underground community. Farren made an interesting analogy between the Angry Brigade and the underground press when he stated in 1999: "[The Angry Brigade] accentuated the ongoing debate among the advocates of direct action and non-violence, but, in practical terms we had to treat them, metaphorically, as another rock band looking to make their name." The activities of the Angry Brigade weren't universally approved throughout the underground, but the police activity they provoked ensured the likes of *IT* and *Friends* would continue to support the Angries over the establishment any day.

The Angry Brigade was a measure of how much had changed by the early seventies, and a number of underground bands played benefits for those arrested in connection with the bombings. One of these bands, Third World War, displayed a rare radical bent. Comprising Jim Avery and Terry Stamp (two session musicians from Shepherd's Bush), Third World War were uncompromising in the revolutionary rhetoric espoused in their lyrics, and something of an anomaly within the underground, looking and dressing more like suedeheads — a subculture evolved from skinheads.

The band addressed working class issues, such as the daily grind and the struggle to make ends meet, as on Working Class Man. Another song, Shepherd's Bush Cowboy, has references to boozing, skinheads, "queer bashing," gambling, prostitutes and football hooliganism, ending with the eponymous protagonist's imprisonment. Other songs (MI5's Alive, Ascension Day, Preaching Violence) advocated the overthrow of the monarchy and government by means of violent revolution.

Seeing Third World War perform at Northern Polytechnic, Mick Farren was impressed enough to say in an *IT* review (Apr 71): "They are essentially Britain's MC5... they play simple uncomplicated hard rock romping and stomping, and sing lyrics that stem from Dagenham factory floors, preaching violence against the bosses and the rest of a hostile society." He called Ascension Day (in *IT*, May 71) "one of the best street fighting songs since We Shall Be Together."

UNDERGOING A significant personnel change in 1972, the Pink Fairies finally had enough of playing their part in the revolution and had designs to reach a wider audience. Drummer Russell Hunter told *Melody Maker* (Oct 22, 72): "this summer there were hundreds of bands prepared to play at those gigs under the motorway, so did people really want to see us every week? I'm sure not. Now the precedent has been set, it's not necessary for us to do it all the time."

The Fairies never really did reach a mainstream audience. Their old running mates Hawkwind did, however, and hit the top ten in the summer of 1972 with Silver Machine. It was proof indeed that commercial success could be possible, while maintaining a degree of hip within whatever was left of the underground.

Hawkwind's most controversial song, lyrically at least, came a year later. Its release coinciding with an intensive IRA bombing campaign on the UK mainland, the BBC refused to play the follow up single, Urban Guerrilla, and it was withdrawn by the record company.

THE TIMES had changed and with it the underground. Continued police harassment helped contributed to its demise — the high profile obscenity trials of *Oz* in 1971 and Mick Farren's *Nasty Tales* comic in 1973 being obvious cases in point. The underground press and community bands had fed off, and thrived on, the support of one another. Now this relationship was gone. The country at large was in one hell of a mess, with crippling industrial action in the form of miner's strikes, the three day week, fuel shortages, rising inflation, and IRA bombings. To quote Marcus Gray: "Come hard times, people would

rather party than revolt." In Britain, the youth fiddled while Rome burned in a new scene of stack heels, glitter and glam. Underground music went even further underground, and adapted itself to the hippy travelling lifestyle that had developed out of the early free festival scene. This nomadic culture revolved around an annual festival circuit, the main one being Stonehenge, and flourished throughout the seventies and early eighties until outlawed by the Thatcher government in 1985.

If all the main proponents of community based activity had effectly fallen by the wayside with the onset of punk (Hawkwind being the exception), its influence on punk and subsequent movements is not inconsiderable. Shortly before punk hit national headlines, Mick Farren wrote for the *NME* an article entitled "The Titanic Sails At Dawn." Recognising the stirrings of the nascent punk movement, Farren's now somewhat seminal treatise advocated taking "rock back to street level and starting all over again" in order to challenge the increasingly stagnant music scene. Within months the Sex Pistols released Anarchy In The UK. When the Pistols swore on the live Bill Grundy Show a parallel could be drawn with the David Frost Show six years earlier, and the furore caused by the American Yippie radical Abbie Hoffman and representatives of the British underground. In simplistic terms, the punks had more in common with the sixties counterculture than they'd care to admit. A strong anti-establishment thread ran through the core of both, and the later anarcho-punk movement became closely affiliated to the free festival scene. This whole festival-cum-travelling culture later mutated and fused with the more anarchic aspects of rave culture, such as alternative community based collectives like Mutoid Waste Company and Spiral Tribe, culminating at Castlemorton Common Festival in May 1992. And so it continues. Whilst there is still music and politics, and the potential for rebellion... mozic and the revolution anyone?

Rich Deakin is the author of *Keep It Together! Cosmic Boogie with the Deviants and the Pink Faries* (Headpress 2007)

Art: Dan White Text: Joe Scott Wilson

Brotherhood.

by Joe Ambrose

Nineteenth century Irish political intrigue through the prism of the FENIAN BROTHERHOOD, a secret revolutionary organisation that sought, by military means, to drive the English out of Ireland. Their own battles against colonialism ended in abject failure but they remorselessly rose from the ashes of their disappointments. They changed their name to the Irish Republican Brotherhood (IRB) and, in 1919, the IRB gave birth to the Irish Republican Army (IRA), which eventually achieved some the Fenian's long cherished ambitions. Fenians were sophisticated men of letters who enjoyed Parisian society and who thrived in Civil War-era America.

IN OUR own time even our radical political revolutionaries have to be photogenic or reasonably media friendly. Che established the tradition and Osama, alive or dead, keeps it alive.

It was not always thus. The nineteenth century revolutionary image was that of a bearded biblical besuited bug-eyed male. Fierce moustachioed men fulminated in coffee houses, lived in damp dark dank accommodations down Parisian backstreets or in the less salubrious parts of London or Dublin. It was the great era of the conspirator; the anarchist, the Zionist, the Marxist — a world of bomb factories, pamphlets, short lived newspapers, long and often awful, vindictively imposed, terms of imprisonment. Very little success achieved in pursuit of, depending on one's point of view, high ideals or low intentions.

The Fenian Brotherhood, like the anarchists, caught the popular imagination. Like the Islamic resistance in our own time, Fenians were allegedly everywhere. They tired to invade Canada. They let off bombs in London. They were a part of the political and judicial establishment in the USA. They were escaping from British imprisonment in Australia. They wrote more books than the Beat Generation, founded more newspapers than Rupert Murdoch.

Fenianism got going in the 1850s but the founding father of violent Irish separatism was Wolfe Tone (1763–98). During his student days he was something of a drinker or party animal. While still at Dublin's Trinity College he eloped with a mid teens girl called Elizabeth and changed her name to Matilda, presumably because he didn't want his wife to bear the name of a prominent English monarch. She outlived her rebel husband by fifty years, dying in America. The fact that the Tone family, after the revolutionary leader's death, passed their time in the States played some part in the obscuring of Tone's virulently anti-America views.

It was Wolfe Tone who gave to Irish separatism some of its most basic tenets and most fervently cherished ideals. Tone and his movement — the United Irishmen — were as radical as a revolutionary organisation could be prior to the evolution of socialist and anarchist theory. Tone said that, "If the men of property will not support us, they must fall. Our strength shall come from that great and respectable class, the men of no property."

It was 1791 when Tone, in cahoots with a number of Ulster radicals, established the United Irishmen. Tone, a fan of both Thomas Paine and of French revolutionary Danton, confidently led the organisation's left flank. A free-thinking character almost eccentric in his liberalism, he believed that only revolutionary means would persuade a well established and well padded Protestant kleptocracy to give up a lifestyle that obviated the interests of the majority Catholic population.

By 1794 the United Irishmen were looking longingly towards revolutionary France for a solution to the problems they perceived in their own country. The French Revolution was one of the most important European developments since the emergence of Christianity as the dominant religion on the continent.

It seemed to provide a quick fix solution to all of the world's ills and seemed, like the 1917 Russian Communist revolution, to be a fundamentally life changing phenomenon.

The English state, which declared war on France and its revolution in 1793, dreaded the spread of Parisian revolutionary ideas. They regarded the emergent Irish Jacobins with classic right wing fear and loathing.

A French Revolution fellow traveller called William Jackson visited Ireland on behalf of the French Committee of Public Safety, the dominant political force in Paris. Jackson met up with Tone, who led him to believe that Ireland was ripe for revolt. In 1794 Jackson was arrested and charged with treason against England. Various United Irishman were rounded up, their papers seized, and many of their leading lights fled to France. Tone, rather peculiarly for an unremitting revolutionary, used his social connections in high places to cut a deal. He was allowed to go free and to immigrate to the United States, arriving in 1795. Prior to his departure Tone made a secret pact with other United Irishman that they would never stop their political efforts, "until we subvert the authority of England over our country."

He didn't much like America or the Wasp establishment he encountered there. He found the people of Philadelphia to be a, "churlish, unsocial race, totally absorbed in making money." "I bless God I am no American," he wrote to an old Irish friend. Offered the opportunity to become a farmer involved in taming the "Wild West" he commented laconically, "As I have no great talent for the tomahawk, I have therefore given up going into the woods."

Tone's political sympathies and anti-American prejudices ensured that, for the next fifty years, Irish separatists inevitably looked towards Paris, rather than towards the States, for salvation.

Much later, in 1848, Paris was still the first port of call for the fleeing Young Ireland rebels and conspirators but, eventually, they moved their centre of operations to New York where they founded the Fenians, an organisation inextricably linked into American structures and thought processes.

Unhappy in America, Tone received letters from revolutionary friends back home lamenting the state of Ireland and encouraging him to make his way to

Paris. He didn't need too much encouragement and, in February 1796, the vivacious fun loving Tone washed up in the equally vivacious and fun loving, but dangerous and shark infested, Paris. The guillotine was awash with aristocratic blood.

He soon had access to senior figures in the Revolutionary establishment — men interested in exporting their revolution who were reported as being impressed by his energy, sincerity, and ability. He was given a commission in the French Army and assured a meaningful French military expedition would be put at his disposal in order that the British could be driven out of Ireland. He had several audiences with Napoleon, a man on the way up, but this pragmatic whiz kid was less inclined to liberate Ireland than some of his comrades.

In December 1796, a French expedition containing some 14,000 men, set sail from France accompanied by Tone. They tarried a while near Bantry Bay but, due to bad weather, were unable to reach land.

The diaries that Tone kept during his time in Paris represent some of the finest writing there is by an Irish political rebel. Full of the quickness and clarity that defines all good writing, they allow this unrepentant troublemaker's exuberant spirit to reach out across the dusty centuries and to touch us. Short of money, hoping for the best, drunk again, Wolfe Tone speaks to us in a shockingly modern way:

T'was a sad rainy night, but the morning is fine. I think it rains as much at Paris as in Ireland and that kills me. I am devoured this day with the spleen and everything torments me. Time! Time! I never felt the taedium vitae [ennui] in my life, till the last two or three months, but at present I do suffer dreadfully that is the truth of it. Only think, there is not at this moment, man, woman, nor child in Paris, that cares one farthing if I were hanged, at least for my sake. Well, if ever I find myself at Paris, Ambassador from Ireland, I will make myself amends for my former privations; "I will, by the God of war!" And I will have PP here too, and I will give him choice Burgundy to drink and he and I will go to the opera together, and we will be as happy as the day is

long. "Visions of glory, spare my aching sight." This is choice castle building, but what better can I do just now to amuse myself?

In 1798 a United Irishman revolt broke in Ireland. In some places this rising was characterised by brutal sectarianism. When the revolt failed, large numbers of Catholic Irish were slaughtered with much talk of rape and desecration. Tone, still in Paris, persuaded the French to send a small military force to Ireland in support of the rebels. He travelled to Ireland with the force and, when they were defeated, he was captured and sentenced to death. He cheated the gallows by attempting suicide in his cell, dying a week later. He became, and remains, the iconic hero of Irish militancy.

Nothing much happened after that, until 1848 when the Young Irelanders, sophisticated cosmopolitan writers and theorists, made their Francophile plans in the coffee houses of Dublin but struck out for their principles in and around County Tipperary's rainy streets and hills. Their romantic but unsuccessful agitations soon gave rise, seamlessly, to the Fenian Brotherhood, a covert revolutionary belief system. From the ashes of Fenianism arose the twentieth century Irish Republican Brotherhood (IRB). In 1919 members of the IRB, styling themselves the Irish Republican Army (IRA), started and won the Irish War of Independence.

Thomas Davis (1814–45) was the youthful intellectual who set the agenda for Young Ireland. He found the entire concept of "Ireland" to be in a poor state, its people ignorant of a bright heritage and colourful past, and he set about restoring — or inventing — Ireland's past national glories and dignity. In 1842 Davis and his friends took a stroll in Dublin's massive Phoenix Park. While walking, they decided they would found a newspaper, *The Nation*, which would take on board, broadly speaking, the French republican ideal.

Within weeks *The Nation* reached a circulation of over 10,000, making it the best selling paper in Ireland. Passed from hand to hand or read aloud to gatherings of young men, its success and influence was immediate. At a time when widespread famine in Ireland was challenging the union with Britain, *The Nation*'s popularity did damage to that connection.

Davis' best known ballad, still widely admired and sung in Ireland, was A Nation Once Again. The song is proof positive of Davis' forcefully held belief that the concept of Irish nationhood could be nurtured through popular ballads. According to Professor Malcolm Brown: "Davis was as avid for music as any other Irishman, and one of the few surviving glimpses into his early youth depicts him listening in tears to the old airs played on a fiddle by 'a common country fellow.'" Davis felt that it was "the duty of every patriot" to make the fullest use of Ireland's love of music since, Professor Brown pointed out, "a fine old tune could escort a good idea past barriers of indifference at any social level."

A Nation Once Again is Dylanesque in its understated powerfulness; it has now survived almost three centuries. The superior recording, by Luke Kelly and The Dubliners, can be readily heard on YouTube. Dull would he — or she — be of soul who could resist the temptation to sing along, experiencing, if only for a moment, a desire to see Ireland, long a province, be a nation once again:

When boyhood's fire was in my blood
I read of ancient freemen,
For Greece and Rome who bravely stood,
Three hundred men and three men;
And then I prayed I yet might see
Our fetters rent in twain,
And Ireland, long a province, be
A Nation once again!

Chorus: A Nation once again,
A Nation once again,
And Ireland, long a province, be
A Nation once again!

And from that time, through wildest woe,
That hope has shone a far light,
Nor could love's brightest summer glow

Outshine that solemn starlight;
It seemed to watch above my head
Through foreign field and fame,
Its angel voice sang round my bed,
A Nation once again!

The failed 1848 Young Ireland rebellion was kick started by a mass meeting held on Tipperary's Slievenamon Mountain during July 1848. This mountain enjoyed both local and national symbolic fame. Folk singer Liam Clancy explained its exotic appeal: 'It is shaped like a beautiful female breast and on its summit sits a cairn of stones, like a nipple. The name Slievenamon comes from the Gaelic, *Sliabh na mBan*, the mountain of the women... Some say the mountain got its name from the profile it presents when seen from the town in which I was born. A more intriguing story tells how the legendary giant Fionn McCool would need a new wife each year and, because of his mighty demands, would put all the candidates vying for the job to a test. On a certain day of the year they would all race to the top of Slievenamon and back. The winner, he considered, might have the stamina to cope with his virility for the next year.'

Given the tense circumstances, a policeman was sent to the Slievenamon gathering to collect evidence. In the early morning he reported back, church bells rang out, summoning protestors.

Future Fenian leader John O'Mahony led a large crowd towards Slievenamon. These people marched in military formation but, significantly, no leader was seen to give them anything that could be construed as military orders or instructions. Because O'Mahony didn't give out any such instructions, he was not arrested when five other individuals were charged, the day after the meeting, with giving military commands.

Those arrests gave rise to a protest meeting. The escalating subversive buzz within the nationalist community made the authorities tense and some minor local radical leaders were arrested. Rumours began to circulate that the police had arrested Young Ireland leader Michael Doheny who, along with John O'Mahony, would eventually found the Fenian Brotherhood.

A very minor rebellion took place in Tipperary but was soon, and effortlessly, routed. The Young Irelanders either disappeared or were arrested. John O'Mahony went initially to Paris and subsequently to New York. John O'Leary, the leader of a gang of Young Ireland stragglers, tried to keep the fight going without any real success. He, with a handful of other junior members of Young Ireland, set about organising a covert anti-British organisation, complete with an oath of loyalty and a commitment to ending the union with England. John O'Mahony, cowering in Paris, was very much in league with them on this conspiracy.

The socialist leader James Connolly, who helped found the Irish Republic in 1916, said that the Young Irelanders had been handed 'revolutionary material' and that they were 'unfit to use' that material. However, an ideal took shape within rebel hearts which would never lie down or back down, no matter how hopeless the odds.

In 1855 Michael Doheny, by then practicing law in New York, brought together, in his offices, the men who founded the Fenian Brotherhood. In 1858 John O'Mahony and Doheny persuaded James Stephens to set about building an Irish Fenian organisation which could coordinate its efforts with those of the American organisation. Stephens was known, within the organisation, as the Chief Organiser.

The Fenian Brotherhood's leaders were an odd, dark and gifted bunch. Stephens was a long-winded, arrogant schemer, ruthless and ultimately incompetent. John O'Leary, in effect a trust fund kid, was a bibliophile and a curiously modern man of refreshingly sophisticated opinions. Michael Doheny was a troubled, idealistic, rough diamond on a doomed trajectory. Charles J. Kickham, blind and half deaf, took his place at every Irish hearth via the sentimental maudlin ballads he wrote and via his novel, *Knocknagow or the Homes of Tipperary* (1879).

None was odder than the scholarly, passionate, perpetually cash strapped John O'Mahony who ended up in New York leading a fixated life which resembled, in many ways, that of the heroin addict.

Fenians took an oath of allegiance to an Irish Republic, swearing to take up arms when called upon to do so by their revolutionary leaders.

By the early 1860s Doheny was dead and John O'Mahony was temporarily the undisputed leader of the Fenian Brotherhood in New York. The Brotherhood, despite having Irish born leaders, came to perceive Irish separatism through the prisms of American ideology, American capital and American requirements.

Over in Ireland Stephens travelled the land, disguised as a hobo, secretly recruiting. Professor Kevin B. Nowlan has estimated that, by 1864–5, the Chief Organiser's efforts resulted in there being maybe 80,000 Fenians in Ireland and England, plus thousands of secret followers who were members of the British army.

Stephens was behind the foundation of a Dublin based Fenian weekly newspaper, *The Irish People*, in 1863. The ambitions which informed this venture were a desire to emulate the influence which *The Nation* had exerted over public opinion, but it was their involvement with *The Irish People* which indirectly destroyed the lives of quite a few leading Fenians.

John O'Leary was editor-in-chief. O'Donovan Rossa, Thomas Clarke Luby and Charles J. Kickham were his editorial staff. Once the paper was gone to the printers the team would usually retire to some tranquil surroundings to unwind. These gatherings tended to be frugal affairs, as befitted those living the revolutionary life, but for one such soiree a supporter gave them a veritable banquet. 'After the wild duck and snipe, which had come all the way from Cape Clear,' wrote Kickham, 'there came walnuts and oranges. It is fair to admit that there was also a decanter of what seemed to be the very best Irish whiskey, as Luby and O'Leary appreciated a stiff tumbler of whiskey punch... The "Chief Organiser" did not affect the more national beverage, but seemed to have a decided relish for a glass of Guinness' porter. Methinks I see him now — Shakespearian head, flowing auburn beard, lady hand, and all — as he takes his meerschaum from his lips, and pointing with the amber-tipped cherrywood tube to the table, says "If some people saw us now, what noise there would be about our luxurious habits!"'

O'Leary had inherited an income of several hundred pounds a year from his father and, prior to his involvement with *The Irish People*, was quite content to potter around Paris buying and reading rare books. Someone who didn't much like him said that he was, 'reserved, sententious, almost cynical; keenly observant, sharply critical, full of restrained passion.' The burden of editorship rested heavily on his shoulders. Something of a literary snob, he felt that the 'talking and writing people' in Ireland were neither particularly rebellious nor much in favour of armed struggles. Ambitious about what he was doing, he put a great deal of his intellectual energies into finding semi-decent professional writers who might emulate the salon of bright and vivid prose stylists that *The Nation* had access to during its halcyon days. One of the few 'proper' writers that he could rely on was Kickham.

A traitor working in their midst at *The Irish People*'s offices, destroyed them. Twenty three Fenians were arrested including O'Leary and Kickham.

Nationalist propagandist AM Sullivan reported on O'Leary in the dock: 'His hair is dark, long, and thick, his moustache and beard are of the same colour, the latter flowing profusely over his breast, his prominent Roman nose and deep piercing eyes, set beneath fine eyebrows and a noble forehead, give an air of great command and determination to his countenance.'

O'Leary, Kickham and the others got long and cruelly enforced sentences. O'Leary and Kickham later emerged into freedom, in their different ways, as damaged goods. O'Leary never liked to talk about his time in prison. Movingly, and with some dignity, he later said, 'I was in the hands of my enemy.'

Fragile Kickham's health collapsed during his incarceration. His abuse at the hands of his captors was raised in parliament in 1867. He was held in solitary confinement at Pentonville, subsequently transferred to Woking's hospital prison, and finally released in 1869. By then he was almost totally blind.

When O'Leary got out of prison he threw himself into life as the conscience of Fenianism. Whereas, awash with American sentimentalism, the movement gradually drifted off into intellectual shamrockery, nothing of that sort informed the severe, cerebral, O'Leary.

He loathed the popular Fenian ballad God Save Ireland and was affronted when, returning in triumph to Ireland after years in jail and exile, his welcoming brass band played that tune. He once undertook an undercover Fenian fundraising trip to New York in discreet disguise. When he landed on the other side of the Atlantic a brass band awaited him on the Battery pier and he was marched up Broadway, where a speech was demanded of him.

When Kickham was released he devoted himself to writing and, despite his disabilities, enjoyed phenomenal success. His novel *Knocknagow* became one of the most popular of all Irish novels, and was still being widely read in the 1950s. *Knocknagow* attacked the landlord system in Ireland and, by implication, British rule which it perceived as underpinning that system. WB Yeats said that it was 'the most honest of Irish novels'.

The Fenian movement was re-organised in the 1870s with a new constitution. Thereafter it was mainly known as the Irish Republican (of Revolutionary) Brotherhood. Kickham headed the secret council that controlled it.

WB Yeats, correctly described by historian TW Moody as O'Leary's most distinguished disciple, said that he was the 'handsomest old man' he had ever seen, and that, 'from O'Leary's conversation and from the Irish books he lent or gave me, has come all I have set my mind to since.'

Yeats wrote that romantic Ireland was dead and gone, and with O'Leary in the grave. Nothing could have been further from the truth.

Joe Ambrose is the author of *Chelsea Hotel Manhattan* (Headpress 2007)

David Kerekes, aged seven, contemplating Headpress and orange pop.

HEADPRESS MAPS
By HANNAH BENNISON

Several exploded views on the pages that follow.

HEADPRESSLAND
Art by RIK RAWLING

Valley of Accelerated Emotion where a man once leaned upon a tree and watched the road to the cemetery. He was doing the Good Samaritan gig, or so he said. He wore kid gloves but his real hands were deep in his pockets. And he lied about his mother.

HEADPRESSLAND
Art by LOUIS PRICE

Spoken — a city built upon every word spoken by children over a twelve month period. In the centre is the invisible cathedral and to the east the gravity reserve tanks, where protestors made an unauthorised elevation on the word "banana" last Sunday.

HEADPRESSLAND
Art by JAMES FLETCHER

The River of Wolvertoons. When the bridge across the river of Wol-
vertoons is down one should avoid the forest. "There will be no backdoor
action here," she said. "You so disappoint me," he replied. And with that the
forest became treacherous and slipped another inch into the mist.

HEADPRESSLAND
Art by DOGGER

Flying Starfish. The fish had been dead for so long they had started to float. The living fish took this to be a step up the evolutionary ladder and in their tiny fish minds they floated, too. To the people of Starfish Heights the smell was unbearable. Cleaners came for fuzzy fish.

PEOPLE WHO READ HEADPRESS
Illustrations by DR STEG

IVAN: Ivan misses the bus because he is ill prepared to run in his flares. "The girls all think I'm pretty smart but I dress terrible."

BERNARD: Bernard works in a brewery and eats salt in the morning so that he may drink more in the afternoon.

MR SPON: He was being honest with Jackie. "Jackie," he said, "to be honest with you, tell me what I should do on this tour. Not a holiday."

The Dr Adolf Steg Notebook, Diary & Planner is available for Christmas from Headpress.

PEOPLE WHO READ HEADPRESS
(ILLUSTRATION: DR. STEG)

IVAN

Ivan misses the bus because he is ill prepared to run in his flares. "The girls all think I'm pretty smart but I dress terrible."

BERNARD

Bernard works in a brewery and eats salt in the morning so that he may drink more in the afternoon.

MR SPON

He was being honest with Jackie. "Jackie," he said, "to be honest with you, tell me what I should do on this tour. Not a holiday,"

Professor Soledad answers YOUR letters...

DAVID KEREKES [reading letter]: "I've only ever ha telephone sex with my boyfriend. There's no physica contact and it's over in seconds for him. I'm twenty ti and he's twenty one. We met online and we've neve seen each other face to face. We live hundreds of mi apart so telephone sex is the only option. Do you think I'm a turn off for him and that's why he can't go for long?"

PROF SOLEDAD: Is she schizophrenic?

DAVID: It doesn't say. It doesn't say if they have sex on the phone or with the phone. Let me read it again. "I've only ever had telephone sex with my boyfriend... Do you think I'm a turn off for him and that's why he can't go for long, you see." He doesn't last long.

PROF SOLEDAD: Well, it's phone sex. That person is having sex with the phone. Yeah. A

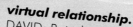

virtual relationship.

DAVID: But why don't you think he's lasting too long? That's the question.

PROF SOLEDAD: Get a bigger phone.

DAVID: We'll go onto another one. "I was conned into getting my girlfriend pregnant. I want to be a proper dad but I don't love her. I'm twenty two and she's twenty one. We met at university and she was a great friend but I never truly fancied her. To start she's overweight, which I find a real turn off. I said I'd help her to diet but she never made any effort. Still I grew fond of her and we slept together sometimes but I didn't have a real connection with her..." It goes blathering on like this. She's gets herself pregnant. "I don't love her but I can't leave her either. This situation is driving me mad."

PROF SOLEDAD: When he was on the bouncy castle he wasn't mad, was he? That was the bouncy castle. Well, for him... what do you say, man? What do say to an individual like that? Except... the child will come into the world and he may learn to love her

they seem to be out of step. When one's up for it one's down for it; so it's not harmonising.

DAVID: Maybe they should move to another room?

PROF SOLEDAD: Maybe she should play hard to get. It ain't gonna work... See if you've got another letter that's easier to deal with.

CALEB [interrupting]: Remember when you took the piss out of me when I was in a similar situation?

PROF SOLEDAD [shouting]: I don't take no piss out of you!

CALEB: "Throw the bitch out! Get her over here and slap her fuckin' ass!"

PROF SOLEDAD: You were about to sink

...body into that?

DAVID: This is what we're asking you.

PROF SOLEDAD: I don't like that, quite frankly. I don't want anybody sucking my toes, I'm telling you. Forget it, that's not happening. That's the deal.

DAVID [reading another letter]: "...I feel low, used and unloved."

PROF SOLEDAD: She's only twenty eight?

DAVID: Twenty seven.

PROF SOLEDAD: That's a tough one. Because you're having sex with someone don't expect them to raise your child. I don't know how to arrange something between her and her old man because

Send your letters and questions to Prof Soledad, c/o Headpress, Suite 306 The Colourworks, 2a Abbot St., London, E8 3DP, UK. Email: letters@headpress.com We are sorry but no personal correspondence can be entered into. The Professor is VERY BUSY.

into fuckin' oblivion! That's what you were gonna do!

CALEB: The kind of advice you gave me—

PROF SOLEDAD: You had me with some psycho fantasy business. All these "yes men" talkin' all this crap. The longer you stay there the worse it's gonna get for you.

CALEB: What you need to do is apply the wonderful logic you applied to me in my situation to these lovely people here. Just pretend they're me.

PROF SOLEDAD [referring to letter writers]: I don't know them, I'm tellin' you!

DAVID: "Cultural differences." What do you reckon to cultural differences?

PROF SOLEDAD: That's a tough one. He's in a bind. He has a cultural problem. That's a bind.

...ne minute

later on. Meanwhile the options are get your woman to lose some weight or get another woman.

[CALEB SELAH ENTERS THE ROOM]

DAVID: "I lose my erection as soon as I get near a woman.... Sorry, as soon as I get near a naked woman. I'm thirty seven and I've had four long-term relationships — I really stand up to the occasion — but as soon as the woman strips down to nothing. I flop. Everyone I've spoken to says I'm okay physically and it's something psychological. How can I unlock my brain so I can carry on with sex?"

PROF SOLEDAD: First of all, the brain is in the wrong place. That's why they call it a "head". And it seems like the

guy is getting cold feet. He's had four relationships? He should be able to get over that. He should have had enough practice by now.

CALEB SELAH [singing]: V-I-A-G-R-A. La la la. Viagra." If you can't do that, get some online. And if you go online get some valium for afterwards so

Go to the doctor, say, "Hey look, give me some

you can get to sleep without a boner.

DAVID: Foot fetish fears, this one, professor: "I get really turned on by my girlfriend's feet. How can I tell her? I'm twenty five. We've been together three months. I've always been fascinated by women's feet. I love my girlfriend and want to stay with her but her feet are a particular turn on. I'm aroused as soon as her feet are near me. When we sleep together I hold her feet all the time. I would love to kiss and suck her toes. I think she has some idea I like them but how can I say what I feel?"

PROF SOLEDAD: How do they sleep? Is that how they sleep? Head and tails? Is that how they sleep?

He embraces her feet?

DAVID: That would be a giveaway, wouldn't it?

CALEB: It's a way to get kicked in the fuckin' face, like I do.

DAVID: "I think she has some idea I like them but how can I say what I feel?" Do you think he should?

PROF SOLEDAD: Just keep on carrying on. That speaks for itself. Keep on carrying on with what he's doing with the toes.

CALEB: He wants more, though. He wants more than he's getting.

DAVID: He wants to kiss and suck them.

PROF SOLEDAD: Is he not

LEFT: **John Sinclair** (centre) in his element, Handa Wanda's, Mardi Gras 2008.

BOTTOM: **The Nuns**, Dirty Water Club, 2008. Photo: James Dunbar

The future now!

by Caleb Selah

MELTDOWN: MC5 + Primal Scream
Royal Festival Hall, London, Tuesday, June 24, 2008

THE REVOLUTIONARY spirit from the warriors of the 1960s and the present was fully displayed onstage at the Royal Festival Hall this Tuesday evening by the MC5-DKT and Primal Scream.

The night began for me when I was guided into the green room to meet the MC5 posse by the legendary musical fixer Mr Dylan Harding. Present were Michael Davis (bass), Dennis "Machine Gun" Thompson (drums), Greg Thomas (the sax player from Funkadelic, who Mr Harding had managed to get involved), and John Sinclair, the famous beat poet and the ex manager and spiritual guru for the MC5. The banter was pure Detroit: Davis: "Motherfucker, you needed a manager when you were managing us!" Sinclair: "Fuck you, your fucking old man said that."

On stage MC5-DKT performed with the addition of William Duvall from Alice in Chains on vocals and the guitarist guy. Hearing them smash the fuck out of Kick Out The Jams was mind blowing, and an incendiary Ramblin' Rose proceeded to blister the walls of the hall. These were no damaged goods or a fucking cabaret act: Kramer's moves were better than Townshend forty years ago, and he assaulted his guitar like a cross between Son House and Jimi Hendrix. The rhythm section was a motor city car plant in full flow.

Primal Scream had opened the evening and returned to the stage to join the MC5-DKT for a short set that culminated in the awesome Black To Comm, halfway through which, for maximum dramatic effect, Greg Funkadelic began to blow like Pharaoh Sanders. Then, for the first time in more years than anyone cared to count, John Sinclair appeared, looking like a cross between William Blake and Odin, to deliver an impassioned and moving eulogy to the late Rob Tyner in true beatific style.

It was great to see all the young and not so young dudes who have revolution in their heads present: the Primals, Massive Attack, Kate Moss (a kicker out of jams if ever there was one!) and the God like genius that is Jerry Dammers.

After the gig, Mike and Dennis seemed moved close to tears at the ecstatic reaction they had received after so many years of relative poverty, acrimony, plagiarism etc. They asked me is the tide turning back towards us after all this time?

I could only reply that they had kicked out the jams. All of the jams.

||

"Dr Gröss, we meet at last."
Bad crema in Guanajuato, Mexico.

by David Kerekes

OCTOBER 2006. Together with business associates CALEB SELAH and BEN LAWMAN, DAVID KEREKES travelled with notebook from London Gatwick to Cancún, the southern gateway to Mexico on the tip of Quintana Roo State. Primed with nothing more than the lonely gringo guide to Mexico and an agenda to keep moving, things started well enough in Cancún and Veracruz, but by the time Mexico City arrived the cracks had started to appear.

THE STORY SO FAR: Mexico City. Our three errant knights are dumped in the deadly Tepito district after dark by an unscrupulous taxi driver and live to tell the tale. They meet American Mike, a mad architect desperate for Latino company. And Caleb gets his balls crushed by a curiously tall hairdresser with long fingers. Before they leave for Guanajuato a man from Colombia tells them the secret of the Pyramid of the Sun and nothing strange happens to the narrator.

BUS TRAVEL is a risky business in Mexico. Air conditioning has been fitted in the better class of vehicle but everyone still leaves the bus terminal under a sign prohibiting hijacking and the carriage of rifles. A functionary with a camcorder (and no flair for his job) records the face of each passenger in close-up as the bus rumbles into life and Frosty The Snowman, the children's Christmas song, begins to play on a loop. Somewhere around Arroyo Zarco on Highway 57, one of the passengers bangs upon the bullet proof box that contains the driver to protest. After all, it is not Christmas and no weather for a yuletide sing-along; in fact it is October and the temperature outside is high enough to trouble the bugs on a dead cobra with visions of Porfirio Díaz. The driver merely readjusts the hat upon his head and informs us, through the medium of millinery that Frosty is going nowhere but northwest, with us to Guanajuato, which is a hell of a lot of sleigh bells.

Guanajuato is a university town built upon silver and gold deposits dating back to 1559, whose elevation is some 6,666 feet above sea level. The sprawl of twisting cobble streets prove challenging to modern traffic and so the bus stops about a mile away from the city centre, which gives Caleb, Ben and myself a splendid opportunity to observe the architecture of faraway buildings and the steep incline that will lead us to them.

We haven't been out of the sun very long when Ben falls sick. It takes hold in the middle of a conversation about Teutl and the best place to go to eat mole (*pronounced mo/lay*), followed rapidly by groaning and a sickly countenance that accompanies Ben to the ground. At first we take no notice because Ben often takes a siesta during the day. Within minutes of booking into the nearest hotel however, the Molina del Ray, we are perturbed to discover Ben collapsed in a heap on the floor of our room, having suffered a massive shitting fit.

~~~~~~~~~~~~~~~~~~~~

**CALEB SELAH**: If you remember the hotel we were in, again a very nice hotel. The hotel was set around a courtyard. It had an inner courtyard. An Atrium? Outside the room we had the kind of bench you'd see in a park. What I didn't

want to do is come bumbling into the room, especially as Ben was ill, making noise and just generally pissing everyone off. I just wanted to sit outside and see if I could get away with smoking a little reefer and just stay on the fucking bench until I felt relatively sane again. The bench wasn't quite long enough for me and I knew the point I had to go to bed would be when I fell off the bench, which sure enough happened, about two or three hours later. I finally lost consciousness, fell off the bench and went to bed.

~~~~~~~~~~~~~~~~~~~~

IT IS ironic that Ben should be the one to fall ill. Ben is the most widely travelled amongst us, and has reminded us everyday for a week that he has visited no less than seventy two countries and fallen ill in not one of them. In Guanajuato he is laid in bed for thirty six hours, effectively the entirety of our stay in Guanajuato. Even the drugs that Caleb feeds him prove ineffectual and at Ben's own suggestion he ensconces himself in a bathroom far away from our bathroom, down the hall to avoid contamination. "It ain't happening," he groans in a state of near delirium from behind the locked door, the words ringing through the empty hallway right up until the moment Caleb and I sympathetically leave to explore the Guanajuato nightlife.

We deduce the problem is a chicken Ben ate from his lap on the floor of the Mexico Norte bus terminal in Mexico City, which even the cleaners considered dangerous before they moved him on. Ben has a voracious appetite and was drawn by hunger to a sore of an eatery called *Pollo Pirate*, the "chicken pirate" or possibly "chicken you escape." Mexicans are really into *crema*, they consider the gloopy white stuff from a can "fancy." Before embarking on this trip to Mexico I was well advised by my friend Michael Lucas to stick to the "*sin crema, sin mayonessa*" route. Ben's pirate chicken was swamped in crema, far too much for the paper plate to bear in fact, it hung from the sides like terror-vines in a sci-fi nightmare. The crema seemed to be controlling him, forcing him to feed from a place on the floor of the bus station.

Guanajuato is notable for things other than Ben's sickness. Our arrival in the town coincides with a major arts festival named after Miguel de Cervantes, the Spanish author of *Don Quixote*, Cal's favourite book he declares. The link between Guanajuato and Cervantes seems an utter mystery to the townsfolk as Cal asks anyone within earshot what the connection is, no answer is forthcoming, merely enigmatic smiles. Yet each year in the month of October they hold a celebration in honour of the Great Knight and his humble, wise retainer Sancho Panza. The whole place is given over to musicians and painters, henna tattoos and small-breasted students in possession of juggling balls, whose siteswap skills are a gentle euphemism for life and how to avoid it. Need I mention the presence of the ubiquitous Pan Pipe types. No. After dark they roll into the Bar Fly on the Sostenes Rocha and avoid life further whilst bumming cigarettes and beer.

A tramp at the entrance grumbles behind his beard while monitoring our progress towards him from across the street. It hasn't rained in weeks and Guanajuato is far from the sea, but each step on the carpeted staircase that leads to the bar of the Bar Fly is soaking wet and stinks of fish. There is no good reason for the stairs to be such a foul pool, and when we ask the tramp about it he leads us back down the street to a karaoke bar where a group of young people amuse themselves to the words of a sad song. Our guide walks to the stage, takes the microphone from their hands and, without missing a beat, sings in perfect voice one verse to the song. He hands back the microphone and leaves.

La vida no tiene valor (Life has no value)
La vida no tiene valor (Life has no value)
Entonces, voy a llorar (So I'm going to cry)
y llorar (and cry)
y llorar (and cry)

Is Cervantes looking down, maybe even the eternally quixotic Quixote? Are they grinning or are their teeth hurting? The words to the old songs manage to

squeeze a wry smile from our destitute friend, who pitches them perfectly at people like us that can't sing for toffee and whose greatest sorrow is the wrong type of beer on tap. Ben knows nothing about such things, furthermore he is in no fit state to talk about anything that makes him shit any more than he has been doing, so we leave the disussion for another day, before forgetting about it altogether. Until now.

~~~~~~~~~~~~~~~~~~~

CAL IS settled into an area of the Bar Fly where the murals begin and a jukebox plays a reggae version of a famous song by a band called Fabulosos Cadillacs. Above this is the sound of someone learning to play the bongos, and above the sick out of synch thudding of bongos rises the angry warlike cries of shirtless men playing table soccer in another room.

If Ben was with us he would have something to say about it. He would call the clientele of the Bar Fly designer hippy twats and not young bohemians, as they might think themselves. There is no light in the black bathroom, so I continue up the stairs to the roof, through a door marked no entry, where I piss under a big sky full of bright stars. Mexican stars are big stars. It's not twinkle twinkle little star, it's — *ker-ching!* — *WE ARE FUCKING STARS!* My hand is up amongst them someplace whilst I struggle in vain not to piss on my trousers.

It is at the Bar Fly we first meet Lío, a girl from Munich, who has freckles and blonde hair that goes long and straight down to her waist. She studied in Liverpool and plaits hair for loose change on the Plaza de San Fernando, a favourite haunt for 'musicians' and jugglers during the festival period. She has many friends and her hair is quite something and I would be a liar if I didn't admit to at least once considering yanking it tenderly. Lío is the unwitting nucleus around which all of Guanajuato and ourselves revolve like bad science, or a bad penny, and the price on her head as a consequence is a hefty one.

Lío is sweating out the reggae knees up, breaking occasionally for a bongo lesson from a Mexican Indian with tattoos. Her eyes are drawn to the corner of

the room and our place as unshaven strangers within it. I place upon the coffee table one Indio beer and for Caleb two tall glasses, each containing as much tequila as will fit in the glass. The table rocks on unsteady legs and soon Lío joins us, bringing with her a girl called Bessie, who has unsteady legs and spills our drinks. Bessie may have been born in combat trousers. She won't stop bouncing but what annoys me more is the terrible spacing between her eyes. She spills our drinks a second time then collapses onto the sofa.

"Your friend is quite unstable," I say to Lío, who replies with an accent that is Teutonic scouse. A voice from another part of the room beats out the phrase "It's only rock'n'roll. But I like it."

Around Lío's neck is a necklace of her own creation that strikes me as neither particularly good nor particularly bad, but I don't really know about such things and I tell her so. This she takes badly and starts to cry. I arrange for Lío to plait my beard but this doesn't hold much consolatory value when Cal offers to buy some of her jewellery for hard cash. Lío is crazy whatever the currency, and as a consequence of the plaiting arrangement I end up in an altercation on a side street the following evening with friends of Lío. Cal ends up in an altercation with her friends, too, following the procurement of jewellery and drugs.

"It's only rock'n'roll. *But I like it!*" says the voice, over the bongos and the reggae music. A deep throaty laugh follows.

The attitude of the room changes when the Mexican Indian with tattoos lights an incense stick and waves it under our noses. He does this to grant Lío "safe passage," and then Bessie chips in. "Look after her," she says, which I take to mean don't rape and don't kill her and don't leave her broken body at the foot of the mountain, which is a bit of a bloody cheek however you look at it. The rest is a blur because I fall into a strange and sudden quandary about my hands.

"Is this a small bottle," I ask Cal, holding up my Indio beer for all to see, "or have my hands got bigger?"

Ever since the energies were drawn at the Pyramid of the Sun in Teotihuacán I haven't been right. My hands have grown disproportionately large, and I suspect my feet will follow. This marks the beginning of the transmission

that will continue with an exhibition of dead people under glass, whose flesh resembles tough leather boots, and climaxes atop the Holy Mountain some days later.

~~~~~~~~~~~~~~~~~~~~~~~

SOME HEADS contain hair and some chins have beards and some men say that hair continues to grow in death. I cannot say if this is true, but the following day I encounter an elderly American in a lab coat in the street who explains that Guanajuato is famous for mummies. "The evidence in the display cabinets in the museum leaves no doubt, gentlemen," says the man, who looks familiar, "hair doesn't ever stop falling out." He points a bony finger up the Av Juárez, the road one must take for the *Museo de las Momias*.

There are places in the world where the natural phenomenon of mummification takes place; Guanajuato in Mexico is one of them. The discovery of the mummies happened a hundred years ago when bodies were removed from the municipal cemetery Santa Paula following the introduction of a cemetery tax that kinfolk were unable to meet. The bodies were in a remarkable state of preservation for reasons to do with mineral deposits or God, and as early as 1900 cemetery workers charged members of the public to see disinterred relatives stacked in the ossuary. They looked worse than the day they were committed to the earth but a lot better than expected.

The stranger in the lab coat pulls at his beard. He considers for a moment the blazing sun and the men in hats discussing gas, he considers the children on their way to school who call him "Dr Gröss" and give him a wide berth. He considers the mummies of Guanajuato. "They are a link to the brink," he muses with a sparkle in one wild eye. "Each one," he feels, "has a different story to tell about their own death."

The Guanajuato mummies have gone toe to toe with the greatest legend in all of Mexico, the wrestler El Santo, along with several of his masked wrestling chums. This kafuffle took place in 1970 in the movie that made the mummies famous, *Santo Versus the Mummies of Guanajuato*. I pick up a pirate copy on

A Guanajuato mummy

DVD at a market stall not far away (there are no legitimate DVDs or CDs in Mexico). I discover later that the disc suffers from pirate incompetence and a scene near the end is locked in a groove, replaying endlessly the moment one masked wrestler steps from a car and walks up a hill to meet the mummies of Guanajuato.

I don't recognise the hill but I am on my way to meet the mummies, as guided by the doctor, who waves from down in the Plaza de la Paz that I should follow the road.

The museum of the mummies is located behind the Santa Paula graveyard, on the outskirts of town, which is a poor area, a far cry from the affluence of the town centre. Families here are faced with the humility of the cemetery tax everyday, and in a cruel twist try and sell picture postcards of their loved ones

to passers-by to help recover the debt. I take from one woman a postcard of a corpse wearing one sock when she tells me it is her grandfather.

Upon an open plot of land a retractable barrier has been erected that leads to the entrance of the museum, suggesting a considerable queue of visitors at the height of season, whenever that might be for mummies. I would guess not October, as I am the only one in the queue. The barrier continues into the museum itself, down an unnecessarily long corridor to where three functionaries sit around a desk. They watch me carefully every step of the way and put me in mind of observers awaiting the demolition of a chimney. Sure enough, when I reach the desk and ask for a ticket they wait a devil's interval before pointing with smug satisfaction back down the corridor.

"*Señor, aqui es donde usted compra su ticket.*" "Señor, that is where you get your ticket," one of the men says. "*Way, way, alli atras.*" "Way, way, back there."

It is a procedural irritant that is well practiced. I walk back up the long corridor, buy a ticket for $50 pesos from a booth that is hidden and walk back down again, handing my ticket over at the desk.

The skin of the mummies is too loose or too tight, and the gaze of their rotten lemon eyeballs, which are sucked into lemon orbits, remain fixed on the last thing in life and nothing beyond or since. They don't see me, but a grin is waiting in each room I visit. The rattle of an air conditioning unit marks the slow passage of time standing still, and while it helps to think that a grin is not a grin, a hollow space is not a mouth, the faces of death are what they are in life, retaining character and personality, if not always dignity. Many female corpses have their genitalia directed at the observer, with breasts flabby and frozen into shapes most women would care to avoid. I suspect this is the legacy of the cemetery workers who first discovered the corpses, providing a vicarious thrill for the visitors in the early 1900s. As if seeing a mummy itself was not quite enough.

Of all the expressions of the dead, and here I slip into the white lab coat of the good Dr Frances B Gröss, there is nothing in the museum that has about it the finality of the child slumped with its head on its shoulder. In the last room

is the tiny riposte to all the dead that have gone before, head on shoulder, all hope is gone, and with it the capacity, *the will*, to look alive.

~~~~~~~~~~~~~~~~~~~~~~

NOT FAR from the Plaza de la Paz are two markets. The first is a craft market for artists with hand printed t-shirts, beanie hats, and leather wristbands embossed with the word Slayer. The other is Mercado Hildalgo, a general market with hot food for sale that attracts big insects of an indeterminate species. A lady is given quite a start when one of these creatures hits her flat in the face. As in every public place in Mexico, the Mercado Hildalgo has a holy shrine at its centre. Near to this is a picture of Jesus peering out from between slabs of shaved meat on a butcher's *callejones*, and near to this Lío from the Bar Fly on a stool drinking coffee with a friend. She greets me with a lively hello. I give her the news on Ben and she nods a nod of understanding before blurting out: "He is a pervert!"

I am taken aback by this. She hardly knows Ben. Fortunately, it is not Ben who is the pervert but Lío's landlord. In her mongrel accent she continues: "He comes into my bedroom when I'm getting dressed, always when I'm getting dressed. And then into the bathroom."

Lío is clearly strung out in more ways than one and I guess she hasn't slept in days.

"The guy sounds a real prick," I say. "Why not simply move out and find somewhere else to stay?"

"*When I'm getting dressed!*" she reiterates, as if therein lies the answer and the answer I should know when all is said and done.

The landlord has a hold over the young people in this town. They all fear him the way that Lío does. Cal meets him in the Bar Fly one night, throwing his deflated Mexican peso weight around, and soon enough I meet him too.

An old man laughs heartily over a newspaper. I say goodbye to Lío to search for a belt for the trousers that have been falling down since Cancún. The man with the newspaper has few teeth but he does have leather goods and belts.

"*Que piensa usted de mis pantalones, amigo? Se caen?*" I ask him. "What do you think of my trousers, my friend? Are they falling down?" He leaves his newspaper to look for a belt that will fit, which is no easy task in a country where male accoutrement is designed only for the cart horse. The next best thing is a belt suited to girl hips with girl colours and a buckle to match. He says the price is $70 pesos. I feel duty bound to barter, in the spirit of sick and absent Ben, but have no motivation to try for much less than $60 pesos, which is ten pence in the world we left behind.

When he attempts to short change me, the old man smiles the sign of confusion. He probably helped banish the Jesuits from Spanish dominions in 1767 for being smartypants. He then spends an inordinately long time deliberating over the coins in his hands before attempting to short change me a second time.

When I have the correct change I fasten my new belt into place. "Perfecto," I say.

"Correcto," he laughs, meaning I had him sussed back there.

"It's only rock'n'roll. *But I like it*. Ha ha ha ha ha ha!"

Among the leather belts and giant insects of the Mercado Hildalgo is a *callejones* whose wares represent the tradition of death and life in Mexico. This table contains potentiates in slim colourful sachets and an assortment of charms to ward off evil and others to bring it on. One of the sachets is labelled *Autenticos Polvos del Odio Sachet* (Authentic Powder of Death), while another is *Legitimo Polvo de la Santsima Muerte* (Official Powder of the Holy Death). Everything looks to have been printed and packaged thirty years ago.

There is also a lot of soap on the table, each with its own exacting function. The box that catches my eye carries a crudely printed photograph of a 1970s man in a business suit, standing astride a woman who fawns in a nightdress at his feet. I open the box to examine the yellow cake inside; it has been crudely manufactured from the kind of chemicals they dump at sea with fumes potent enough to bring tears to my eyes. The inscription on the soap reads *Jabon yo domino a mi mujer* and, according to the instructions, it will turn any woman that washes with it into a loyal and obedient servant. I cannot imagine a wom-

an who would allow such a foul thing within ten yards of her toilet. Flesh would melt like Hiroshima under a mushroom cloud on contact and your sex slave fantasy would become a burn victim nightmare in need of twenty four hour medical attention.

The couple in charge munch distractedly on something from an old tin box.

The sun is at its height when I encounter one of the friends of Lío on the narrow street that runs between 28 de Septembre and Av Juárez, the main drag in Guanajuato. I do not know her name but she cracks open beer bottles with her teeth and as a consequence has cracked teeth. With her is the Landlord, an overly dressed man who runs the young people in this town. He tells me to talk to him because he knows English and the girl with cracked teeth doesn't know shit. He says this as he fixes me a stare as bold as a green car on a summer's day.

Behind me is a place called Sombreros Gonzalez; I don't know what it is that lies behind the Landlord but his head is small and I do not wish to gain the approval of a man with a small head. In this respect, the small head, like the small town itself, becomes a metaphor for the constraints upon individual freedom, a shorthand for all that thwarts the young people of Guanajuato, whether it's a sombrero or a place to stay where they can dress in peace.

"I am a friend of Lío," I tell him, stepping out of his way. He follows me and stands in my way.

"Lío? What is this Lío?" he sneers. "I don't understand this word, Lío."

The girl with the cracked teeth quaffs on a bottle of red wine.

"Talk to me," he says. "Talk to me."

No one understands the word Lío, which is a lie. The Landlord doesn't understand it, nor the girl with the cracked teeth, and not, I imagine, the small group of people that hangs around in the back the way that some small groups do. Is there a secret handshake for the friends of Lío? Her name is spoken a collective eighteen times.

A boy runs by in a t-shirt that has a picture of cartoon breasts on it. I think of a two pesos tip for a slice of pizza and Cal and Ben. After Tepito, Mexico City,

we are afraid of nothing and nobody. I catch the Landlord with a hook from a big left hand that pops the side of his small head, and the penny drops. "Ah, *Lío!*" everybody cheers.

Nineteen times.

~~~~~~~~~~~~~~~~~~~~~~~~~~~~~

ARMED WITH authentic potions of death and *jabon yo domino a mi mujer*, I return to the hotel to find that Cal has packed each orifice of the room with bathroom towels and clothing to avoid seepage into the corridor. He opens the door in boxers and a new t-shirt bearing an image of Don Quixote riding a yellow submarine and pulls me in. The room is thick with a cloud of marijuana smoke and I can barely make out the bottles of tequila and sangria on the other side of it.

"I've lost something and I don't know what it is," he says. "Any ideas?"

The Hotel Molina del Ray in Guanajuato is run by a Mexican Basil Fawlty, a man duty bound to lock himself in his office, draw the blinds and turn everything into an affront against humanity. It is not a good idea to lose drugs in one of his rooms. In this instance two joints of grass.

"Fuck me," says Cal, throwing the blanket and the mattress from his bed. "I had them in my hand two minutes ago, when you knocked on the door."

Cal drags the sick Ben from the bathroom in the hall to help with the search. Wherever they may be, says Cal, they are most assuredly not hiding in Ben's property or mine; particularly not mine, given my parapsychological adversity to any drug but alcohol and painkillers.

After twenty minutes of fruitless searching, Cal is ready to throw in the towel and begins to construct a defence opening with the fact that it is not illegal to possess two small joints for personal use. Ben will hear none of it and refuses to allow anyone to leave the room until the items are found. He reasons that the cleaner may find them. "Cleaners are an unknown quantity," he says, paraphrasing judicial culture in his semi delirium. "Cleaners in Mexico may react badly on discovering drugs."

Soap for ladies

He then offers to extend the search to his own bed but Cal impresses on us once again he would never sink to hiding his narcotics on somebody else. Cal had two joints and now they are gone. Did he have them at all? he begins to wonder. Cal recognises the mild hallucinogenic effect of the dope and he knows paranoia can arise when someone or something hits the Random Play button.

"Well, if *we* can't find them the cleaner will never find them," he determines in a wholly unconvincing manner.

"That's not the point," responds Ben.

The task of locating the two joints has become a Sisyphean task. Outside the window the sun is shining and the universe expands, but our light is a grim and static twilight in the beautiful days of mortal men. The more we look the less we find, until we find nothing but frustration and space and places that do not belong to Cal, places exempt from hiding and losing narcotics, as Cal keeps

telling us. When every item in the room has been overturned and examined and re-examined many times I question the task. I turn to the exempt places and shake my head and shake down my bed. From my bed fall the two joints as thick as thumbs, bouncing to the floor without a sound.

"Aw, man," says Cal. "How did they get *there*?"

It is a good day for Caleb losing things. In Mexico City he managed to lose his phone and by the time we leave Guanajuato he will have lost Ben's phone, both his credit cards, two joints in the hotel room and his spectacles, as well as the charger for my phone, which proves impossible to replace in Mexico. So effectively he loses my phone as well.

I am able to send a short, final farewell back home to Britain before my phone dies and all contact with the outside world goes the slow, agonising way of science without electricity.

"*THIS IS OUR LAST COMMUNICATION,*" the text message reads. "*WE ARE WELL. DO NOT BE ALARMED.*"

With that the phone is dead.

～～～～～～～～

AT A busy street I have stopped to look down at my feet when Lío taps me on the shoulder. She is on her way to meet Caleb, who has promised to buy some of the jewellery that so upsets her when I talk about it. She is very skinny and that's not Cal's scene. He isn't interested in trying to pull her, but says it's nice to chat to someone who's been in Guanajuato for a while and might be able to score something to smoke. I give her an important message to pass on about dead phones, but she is late enough and is gone before I finish.

～～～～～～～～

NOW THAT our lines of communication are down I wait on the steps of Teatro Juárez, the bigger of Guanajuato's three theatres, thinking about how it takes five or six years to become a mummy until Caleb happens to wander by, as I

know he will sooner or later. "An afternoon with Lío and all she could come up with was a pathetic little bag of grass," Cal says. He shows me the jewelry he has bought. "This was after we'd been buying drinks fairly liberally for just about anyone that asks. But the grass was excellent grass, proper Mexican grass."

At Los Lobos, a bar that plays music all night, I wonder how much trouble Caleb can find in the time it takes me to urinate. The gents' toilet in Los Lobos is an unfeasibly large room, but it contains only one bowl tucked away in the corner. I am pissing in it when through the wall comes a very loud sound from Caleb, who is delighted to hear Paint It Black by the Rolling Stones on the Los Lobos sound system.

Mick Jagger once said that Paint It Black had "sitars on it," which is less insightful than another statement he made about the song being "like the beginnings of miserable psychedelia. That's what the Rolling Stones started." The Stones as black as night, reciting Joyce, that's why the cheer from Cal. Now please wash your hands. In the short time I am gone the bar has filled with people, as if everyone was waiting outside for the right moment for someone to fall off the bench.

~~~~~~~~~~~~~~~~~~~~

**CALEB SELAH**: And we moved on to Los Lobos, which is fun and we started drinking... really getting off on the fucking music, you know. Hearing something like Paint It Black in Mexico at full blast begins to bring out the fucking party animal in me. So obviously the next quest is: Where can we get some fucking drugs? I sort of made eye contact with a few people, checked a few people out and I don't remember how we got into the conversation, but I remember we were pretty inebriated. There were three relatively young Mexicans, maybe in their mid twenties, who were claiming they would be able to get me something. So I said, "Go away, hurry up, come back." So they went away, came back and said, "Right, half and hour." We very patiently waited twenty minutes and said, "Right, that's half an hour. What's going on?"

"Oh, it'll be here, be here, here."

An hour later I was getting pretty fucked off and very drunk. So I thought the situation needed to be dealt with and dealt with efficiently and with the necessary amount of implied brutality. So my instruction to you, if I recall, was something along the lines of don't smile. Did I say don't smile?

*"No, no you didn't. I was grinning like a fucking idiot."*

~~~~~~~~~~~~~~~~~~~~~~~~~~~~

CALEB HAS been entertaining tequila since midday. When Lío fails to show up with her drug connection he becomes irritable and turns to a guy whose long hair is slicked back over his ears. I doubt he knows much about the Rolling Stones. The guy places upon his head a hat as wide as his shoulders.

"Espera cinco minutos," he says. "Wait five minutes."

I look around the room through the drag that comes with alcohol. A guy seated across from us beneath a framed poster of the Beatles in their *Yellow Submarine* phase (happy psychedelia to the Stones' misery) is studying hard the end of a cigarette. On his t-shirt is a big letter U. A shirt with the letter U.

"Espera cinco minutes."

If things are going to go awry it should at least be to the measure of a good soundtrack, but the Stones being replaced by terrible records from the 1980s offends my keen musical sensibilities and flips my mind into despair, like the flipping of a circuit. I act upon this with a $50 peso bill rolled up in a napkin with a note upon it, *"'60s mas por favour,"* which I give to the barman. I nudge Cal because five minutes are up. Love Street by the Doors begins to play and the notion that we might leave makes Slick so uncomfortable he takes off his hat again and starts to make reggae moves with his hands and his hips. "I don't like reggae," I tell him.

Underneath the Beatles are the Apple Bonkers and the Snapping Turks and the Blue Meanies and a yellow submarine, and beneath the yellow submarine the guy with a cigarette studies a cigarette.

"We have to leave," I say to Caleb. Mexicans have this habit of making you wait and Caleb is not the most patient person in the world anyway.

"YOUR FRIEND NOT SHOW WE LEAVE!" Caleb announces, six sharp words of bare meaning so meaning won't be lost on Slick. He hits his wristwatch too, which is short for time it is. Cal is well versed in this kind of thing, and he hits his watch once more, drawing a lot more attention than my yelp at Lynyrd Skynyrd and Sweet Home Alabama, which is fighting talk for Neil Young and will normally result in a predictable yarn from Cal.

Slick flounders for something to say in English that might grip us in the absence of his five minute associate. "Meta amphetamine!" he cries out. "It's good!"

Cal considers this. The room considers this. Of the many nefarious substances Cal has tried over the years he has never tried meta amphetamine. (He is still struggling with the concept of metaphysics.) Slick's head reminds me of the department store on the Plaza de la Paz where the only thing for sale is hair gel, a pyramid display of industrial size tubs of gel in the middle of the floor. Into the bar walks the associate with a handshake and I see the air and the sky in Mexico through the door that closes behind him. Caleb looks down at the two pills that have appeared in his hand, which is open like the centre of the universe despite the efforts of everyone to keep it closed and the universe nice, simple and discreet.

"What's this?!" he roars. "Berocca?!"

The two pills don't move, the man in the hat does. "No, no!" says Slick. "Meta amphetamine!"

I saw a Mexican standoff two nights ago and it didn't end in flowers.

"Sounds like bullshit to me," returns Cal, who hasn't a clue but doesn't blink.

The gateway is open to the tune of Crossroads by Cream. Cal removes his glasses and from his mouth the plate that carries his two front teeth. "Look into my eyes," he demands, leaning deeper into the table toward Slick. Not knowing what else to do or where else to look Slick looks into Cal's eyes, a condemned

man and his executioner. Cal's eyes are the stuff of legend, and now that his mouth is missing teeth he's a nightmare too.

The Beatles guy in the big U t-shirt sides up, and with the carrier this makes three of them at least.

"If these turn out to be Berocca," says Cal, "I will kill all three of you." The Mexicans fumble for a reply. "Nuh, nuh, nuh, man," they say. "It's good, man, it's good. It's good. It's good."

"Promise me, Slick," says Cal, "you give me your word. I'm holding you responsible. Not him, or him. *You.*"

Cal now tells a shocking story of how he came to lose his front teeth and how he got the scar that splits his face nearly in two, which may or may not be pure fabrication but instils in our company the fear of the death god because it involves a foul drug deal remarkably similar to the present situation. Consequently Slick can no longer look Cal in the eye because the gringo is crazy. Cal slaps $100 pesos down on the table in payment for one pill. "Not for him," he says of the other pill; there is no place for me with a pill. This completes the transaction and I take Cal by the arm before he can get started on any more knife stories and drag ourselves up Doblado, far away from Los Lobos. He peaks on meta amphetamine and in a bar called Lagardia he continues to peak for the next two hours.

"Fucking hell, okay, 'spretty good," he splutters, smilefully.

Lagardia holds what remains of the night life in Guanajuato, mostly around one big table at the back. Men entertain Cal with tequila and heartfelt tales of old Guanajuato, while I luck out with a man of Chinese extraction from San Francisco who bores me with his Polish girlfriend and the work he's doing in the Arts. Common courtesy obliges him to eventually ask what it is I do, and what it is I'm doing in Mexico.

At this stage I'm not really sure beyond travelling through it.

"A bit like *Fear and Loathing in Las Vegas* but without the lawyer," responds the Chinaman, a smile at the brilliance of finding such a perfect truth.

"We do have a lawyer," I tell him. "He's sick in bed at the hotel."

The night in Guanajuato ends on a bench in the Plaza del Baratillo, two figures in the middle of an empty town spinning tirelessly toward dawn and the rise.

Nobody can know that we travel through Mexico destined for a place with only enough room for two of us and not for three, high on a mountain. Ben is sick. He won't make it back down the mountain. The meta amphetamine that courses through Cal's metabolism in short spiky bursts makes him immune to the cold that has fallen on us. It may also account for the tears in his eyes when he offers me last season's Liverpool shirt off his back and I put it on because I am cold and he is not.

"Man, I am so proud," he says. "I wish I had a camera, you Manc git"

"If you had a camera I wouldn't be wearing it," I tell him.

~~~~~~~~~~

**CALEB SELAH**: I had a couple of missions. My mission number one was to try and find those three guys that I'd obviously misjudged, been very drunk and been very offensive to, and I wanted to apologise to them. So I was going around various bars looking for them. Couldn't find them. So, then I went back to the Bar Fly, which was the bar we'd been in on the first night when we met Lío. I was in there and because I wasn't with you and Ben I just sat at the bar, drinking sangrita and tequila in big half pint glasses as opposed to the little shot glasses. And this guy starts talking to me in English and he says, "What are you doing?" "Well, you know," I said, "I'm just traveling around Mexico for a little while. Just a couple of weeks."

"What do you do for a living?"

"I work in the music business." It's always a good thing to say. Instantly a connection can be made between the dodgy world of narcotics and that particular profession. Anyway, that's beside the point. I'm chatting away to him and he said, "How are you finding it?'

"I have to be honest with you," I said, "I'm pretty fucked off."

"Oh, with this place?"

Authentic powder of death

"Well, not with this place necessarily, but kind of. I come in here for three nights and whilst I love the place, I love the music, I don't like dancing, but, you know, there's lots of pretty ladies dancing. You've got a beautiful bar here. I came in here this afternoon, having had a little smoke and sat on the balcony in the sun looking at your Don Quixote and Pancho Sancha statues just outside the bar and just had a really, really nice time, a really nice afternoon. So I dig your bar, but why can't I buy any cocaine? What is it? What is wrong with me?"

He says, "Ah, cocaine, my friend! For you we need the Wolfman!"

"Right the Wolfman. Does he come in often?"

"The Wolfman will be here."

"Oh, and how will I know when he's here?" I said.

"You will know when he's here. He will find you."

Twenty minutes later, boiling fucking heat, even at night, this guy walks in, mid forties, pockmarked face, floor length leather trenchcoat. He looked like he'd been around the block a few times and then burnt the fucker down. Certainly not the type of person I'd mess around with in a disrespectful way.

He said, "You're looking for the Wolfman?"

"I am indeed looking for the Wolfman."

"I am the Wolfman," he said. "Follow me."

So we went into this thing that purported to be a toilet. It was a darkened room with a trough in it. And when I say dark, there really wasn't much light in there. And he produced these little polythene wraps that were sort of little balls. They must have contained a third of a gram in each one. I looked at them and I said, "Mate, in England you get these lovely little envelopes and you open them up and there's the powder and you chop it all out."

He bites the end off one of these little bags and, as you do with tequila, you put the powder on the little indentation between your forefinger and thumb, he did that with his coke. He just wacked it all onto this little indentation and went [sniff].

"Okay then," I said to him. "Give me three." So he gave me three. "[Sniff] That's nice." Other nostril, different bag. "[Sniff] Yeah, yeah, that's okay mate, that's good. I'll take another five with me." That's about two quid each, and then he said, "My friend, now I want something from you."

"I've paid you. What?" They're always trying it on, like, oh you know, the price is this, now the price is that. He said, "I want that," and pointed to my Liverpool shirt, which I'd acquired the day before for the Liverpool vs Bordeaux match, in the Champions League. It was an out of date Liverpool shirt anyway, wrong sponsors. It was from the season before. But, you know, I liked his style. I said, "Sure, you can gladly have it, but it's all I've got on so I can't give it to you now."

"Well, when are you leaving?"

I said, "We're leaving the Hotel del Morina first thing tomorrow."

"Okay. What I want you to do is leave it at the hotel reception and say that it's for the Wolfman."

"Okay, it's a deal."

I shook his hand, had a few more drinks, came back, sat on the park bench outside the hotel room, did the rest of what I got, took a little bit of medication, chilled out, fell off the bench, went to bed. So that was the Wolfman.

~~~~~~~~~~~~~~~~~~~~~~~~~~~

CAL PULLS out a map drawn on a napkin with a ballpoint pen. The map shows six houses in a desert and the word Wadley next to them. Nothing more. On the reverse of the napkin is a letter of introduction with an illegible signature, to present to whomever it is we find there. Cal acquired the map following a deal with an individual known as the Wolfman. I rub the bruise on my forehead, delivered not by loutish behaviour but a blow from the low doorway of the Lagardia that made me see stars. Big stars. I see from my bruise that the coordinates of our journey through Mexico are not on the plane of latitude and longitude. We thought we were headed north when in fact all along Mexico has taken us steadily upwards, many thousands of feet above sea level. (I looked down at my feet when I should have been looking up.) It is no accident that we are in Guanajuato with a map that has no directions to a place nobody has heard of.

Six towns lead to Wadley, and Wadley comprises only of six houses, as shown in the map. With stars as information I am compelled to sing the words to one of the old songs and remove all of my clothes and run free through an empty town. *"Todo nos hace reir como a dos tarados,"* I sing. ("Everything makes us smile like two mad people.")

This is the price to pay for elevation.

NEXT: San Luis Potosí and Zacatecas

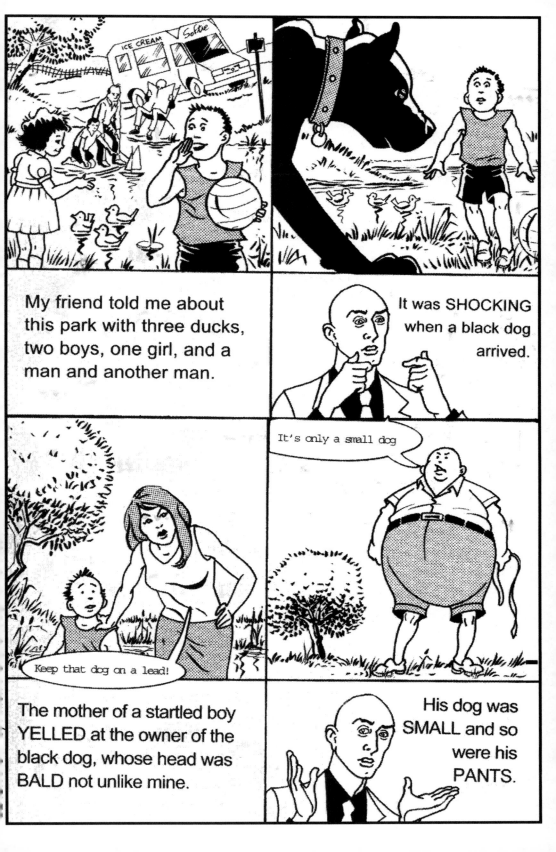

||

"I don't care where we are, you're barred!"

The story of Focus North.

by David Kerekes

SMILE ORANGE are independent filmmakers from the People's Republic of Yorkshire in the north of England. THE HUNT FOR THE YORKSHIRE GRIMACE, a film Smile Orange made years ago, is the story of two down at heel northern comedians. We at Headpress like to champion Yorkshire Grimace as a benchmark in celluloid effluence. On the other hand, Smile Orange's FATLINERS, a film about time travelling wrestlers, is astonishing only because it's so rubbish.

Extracts from the Smile Orange "documentary" THE BOWL were screened in 2006 at the Headpress Song & Dance festival in Dalston and managed to offend the largely vegan pinko audience with its footage of slaughterhouses, octogenarian sex and an army recruitment office.

A pilot for a proposed series called DOCUMENTAL is similar to The Bowl in that it plays around with the documentary form: real people doing real things made to look ridiculous. Before Documental or The Bowl, however, Smile Orange took a swipe at documentary and truth

in FOCUS NORTH, a hit and miss regional news spoof in ten parts that came and went on late night Channel Four in 1999. It never attained cult status, despite some dark and highly memorable stabs at real life, such as the pub-a-van report and the night class for debt collectors.

Of the three people behind Focus North, I talked only to JULIAN BUTLER, the producer and second tallest member of the team.

DAVID KEREKES: Can you tell me about *Focus North*? How it came about?

JULIAN BUTLER: We'd been doing those real dirt cheap feature films, as you know. When we were editing *Fatliners*, me and this guy called Gus [Bousfield] talked about doing a TV pilot, because although we did all right with the films we felt we just weren't getting anywhere. We decided to muck around with the fake "mockumentary" sort of stuff. There were a lot of people doing it so we thought we have a go at it, and did a TV pilot called *Focus North*. We did a proper half hour pilot, which took fucking ages, about a year or something. We made it with five grand lottery money that we had received to make a film called *The Pike*, which we never made. We sent the pilot to a group of people and there was no interest, until Channel Four and 4Later, the stuff Channel Four put on after midnight. The commissioning editor was from Huddersfield and wasn't from a TV background either, so he was a bit more open to stuff. At the first meeting he goes: "I want you to make ten episodes and we'll give you ten grand an episode." I remember writing it down whilst he was still talking. We were trying to keep a straight face writing down the amount we were going to get, 100 grand.

Well, we went back and negotiated and got two grand more. I just remember writing it on a piece of paper and showing it to Bob, whilst we pretended to ponder over it. Then we just went straight into it really. Bob and Gus had just

left their jobs; they were down in London and came back up here to Yorkshire. I wasn't working at the time, so I was all right and I launched into it. But I remember one problem right at the beginning was that Channel Four wanted ten episodes. This was in May or June, and they wanted them by December. We were like, oh easy, easy. When we spoke to him a week later he said: "No, I want them all broadcast by the end of December." So we had to knock two and a half months off the schedule.

Did you manage to film all ten?

Yes, we did them all.

What kind of reaction did *Focus North* receive?

They were doing well. They were getting good ratings and stuff, because they came straight after *TFI Friday*, which is weird. I think we just got a load of people drugged out from that. There was one person who believed one of the stories. The story was a piss take of those road protesters: the council were drilling in a graveyard and had mistaken these bodies in the cemetery for road protesters. So they were digging up the corpses in the graveyard and arresting them and that sort of stuff. Some guy wrote in to say he watched it twice: when it first went out and when it was repeated. He said he watched it and his mother watched it and they were both shocked by it. He couldn't believe this was for real. The guy who was in charge of the cemetery loved it, though. I remember him saying when we arrived: "Well lads, you can have run of graveyard, whatever you want. There's an open grave over there. You can go in if you want but keep a couple of feet away from the coffins." He was really into it; this guy was just *wrong!*

Can you remember much about the writing process?

Fucking, just mental, just like a month of just going mad. It was twenty hours a day towards the end of it. Two computers, shouting and stuff.

I wouldn't describe *Focus North* as comedy as such. You don't sit there and go "ha ha ha". The way I would describe it is "anti comedy."

You mean it's not funny then? When we were writing, we were laughing at bits I guess, but like you said, you're not pissing yourself. I think the problem is that a lot of it is in-jokes. We're not writers, not really. The three of us have known each other since school. There's so many references, and we find them funny, but to other people it's just a barrage of... And then they get the odd gag.

You manage to pull it off well; you're very straight faced about it.

I think that's the only way to do it. We wanted it to look like the original *Calendar* basically, or *Edit 5*, a late night Yorkshire TV programme that went out at eleven thirty and just featured stories from the community. And the story we were most inspired by was about this minstrel, an Al Jolson impersonator called Clive Baldwin. He was from Hull and he talked in an Al Jolson voice, even when he wasn't blacked up. The programme promoted him; that was what was funny. *You're from Hull! What the fuck are you doing?* We realised all these programmes are based on the principal that *this person is good because he comes from where you're from*. This guy was blacked up, but they say: "Aw, look how well he's done, he's from Hull. Brilliant. Well done."

What happened after those ten episodes?

Fuck all, basically. We had to start a company, so that's when Smile Orange became Smile Orange Limited and then, due to massive mismanagement, we got in loads of debt. We were like, forty five grand in debt to the tax man.

FOCUS NORTH
Directors: Gus Bousfield, Julian Butler, Bob Priestley
Producer: Julian Butler
UK, 1999
www.smileorangefilms.co.uk

Queen of the Damned.
An interview with Diamanda Galás.

by Stephen Portlock

*The work of DIAMANDA GALÁS has been branded satanic in some
quarters. PLAGUE MASS was a coruscating attack on the Church's
homophobic response to the AIDS epidemic, and she has continued to
provoke, following it with works on mental illness and on the Turkish
genocide of the Greeks, Assyrians and Armenians. In GUILTY GUILTY
GUILTY, the latest collection of "tragic and homicidal love songs," she
applies her multi octave vocal range to covers of works made popular
by Johnny Cash and Edith Piaf. Diamanda Galás talks to STEPHEN
PORTLOCK about religion, dementia, depression and being Greek.*

**STEPHEN PORTLOCK: I admire you both politically and as a musician,
but, as someone who came from a religious background, for about
five years I wouldn't go near your music. I thought "My God, what
is this woman? Some kind of Satanist?" So do people get nervous
about your music in this way, and how do you feel about it?**

DIAMANDA GALÁS: I think that people can interpret things in many different
ways. I would certainly not want myself to be classified with that banal Anton
LaVey school of Satanism that a lot of musicians aspire to. The kind of work

that I do is really talking about things that I think Baudelaire and other French poets were talking about, deep suicidal misery. When they said the likes of *"O Satan prends pitie de ma longue misere"*—Oh Satan take pity on my long misery—they were really calling to any god that would have them as opposed to the god that represented, say, the main strand of society. These people would walk in the streets in a state of complete poverty, and sleep as much as possible until the morning in which there would be some joy and then try to figure out how to get through the day. Satan, this god who had ruled for a long time was cast asunder, much as they were. I understand that as a person who came from San Diego, not a particularly notorious town as far as art or literature are concerned. It was more or less known at the time I was growing up in it for science or for old folks' homes and beaches. I came out as very isolated from society and sheltered in a home with Greek parents, and my father said Americans were stupid and devils and couldn't trust the Greeks. I had a very paranoiac upbringing.

Was that what you meant when, in a 1992 *Mixing It* interview, you talked about a God created out of despair?

For a person in exile living by himself for a long time, there may be a need to feel that there's someone else with whom to create a dialogue. In the moment in which there is no dialogue there can be a very quick loss of sanity. It can be very scary and I have been through years of treatment for depression and isolating myself from people for many days. I'm still trying to figure out a way to cure myself of this problem.

You once said that the Bible intrigues you. What did you mean?

Certain books of the Bible, such as Leviticus, are books of laws, of a plague mentality which is very predatory. Others, such as Psalms, are writings of despair. These are great juxtapositions. In the Old Testament alone you have the point of view from both the victim and the perpetrator.

Are there religious people who understand your work?

Oh yes. There are different ministers and priests who are very supportive of my work, and when I've been attacked by people on the religious right, they have written in to defend me. I'm not dealing with what are trifling issues. I don't walk around, as anyone will tell you, dressed up in lugubrious garb and trying to look like some kind of goth act. I actually walk around looking like a bag lady in my hometown. I'm more concerned with books and ideas than with how I look.

Are you a religious person?

I believe that human beings are capable of enormous things, but I don't believe in a metaphysical God, though I really wish I did.

Moving on to your background, your father ran a gospel choir.

Right. They cane to our house for many years, and that's where I heard things like Swing Low Sweet Chariot, Is There Balm In Gilead and Early In The Morning. Many of the members were Southern Baptists.

Yet your background is Greek Orthodox.

It's not Greek Orthodox actually. There's been this huge persecution of all the Eastern Orthodox churches and that's why I say Greek Orthodox, though I was raised to be agnostic and am an atheist. What's going to happen to the Greeks if they're not careful is that they're going to be wiped out. As a member of the Diaspora, I need to keep saying Greek to everything because when people consider that you no longer exist, they steal everything from your culture and they put it under their own name.

Could you tell me about Philip Dimitri Galás.

Philip was my only sibling. He was a phenomenal actor and playwright. His work has been performed in the USA and Eastern Europe, especially Poland, and is being published again this year. He inspired me in an incalculable number of ways.

From whom did you inherit your political commitment?

My political commitment is self-generated.

You studied music at university.

Well, after studying with private teachers. I studied cello, violin, and then many years later, I studied voice. But in the university I didn't really study so much as perform avant-garde piano works. And I went there to study bio-chemistry. I wanted to be a biochemical researcher. Unfortunately, I started injecting the drugs myself, and using my voice to record what happens to the mind in different states of consciousness or rigour. Some of the people I was associating with were a bit sadistic so some unpleasant things happened. However, through a teacher, I became introduced to the work of Roy Hart. Hart was a doctor who was in the military and observed the sounds that were made from the soldiers in the war under excruciating pain. He said there's something wrong with our theatre that these sounds are not heard, so he started a theatre company.

Was he an inspiration for the sort of vocal experimentation that you do?

Yes he was, alongside the writings of Artaud and the Grotowski theatre in Poland,

I also understand that you studied under Bobby Bradford, who worked with Ornette Coleman, and that you modelled your voice on the style of the saxophone.

The soprano saxophone. I had to make my voice as shrill and as pressurised as the sound of Jim French's saxophone. In a way I ended up with this certain pressurised shrillness.

Has that had an effect, quite literally, on your body.

Well if you don't do it properly you can hurt your voice. I do it properly so I use diaphragmatic control. However I started studying bel canto shortly after

that, a year later, and I'm glad I did because had I not, I wouldn't be able to sing now.

What did you do after graduation from university?

I did solo voice pieces with my back to the audience. After working with microphones in quadraphonic space, I started using electronic processing. However, it is impossible to go through my entire biography again.

You have talked in the past about working as a prostitute. Could you give some context to this?

This is very personal. It is an old part of my life that can be read about on my website.

You commendably dedicated a song cycle to Aileen Wuornos. However you have also talked about carrying draconian punishment on rapists: "Let the rapist be castrated and raped (forced anal penetration) himself, his house burned down, and the word RAPIST be tattooed on his forehead. Death is too easy a solution; let them live for ever more in shame."

That is absolutely correct. With DNA the rapist can be easily identified, so there are few chances of making a mistake. I have survived many and I know what I am talking about. It changes your life forever and makes you uncomfortable being alone with many individuals for the rest of your life. It prevents you from walking down the street without an attitude of hatred and impending attack, it makes you sensitive to the least sound. It destroys the idea of a natural relationship with an individual one may love greatly. It is a trauma from which you never recover.

I understand that, but I wonder whether some, though certainly not all, rapists may not themselves be deeply damaged people. Is there not a danger that vigilante fantasies may encourage a lynch mob attitude towards the sick and mentally ill?

What do the sick and mentally ill have to do with sociopaths? The sick and mentally ill are very rarely those who engage in this activity.

I am also slightly concerned about the inadvertent stigmatising of people with mental illness in the context of your albums *Schrei X* and *Vena Cava*.

That is ridiculous. *Schrei X* concerns those who have been tortured in confined spaces and often to death, for example stemming from research done by the USA from nazi torture, then shared with Israel and Turkey, among many other nations.

Vena Cava concerns the inadvertent torture and suffering of a patient dying of AIDS and his or her simultaneous state of dementia, which lapses in and out, making the wishes and dictates of the patient suspect to a medical profession who have not even studied the most recent laws of doctor-patient conduct concerning attention to sensate definition that is mandated by Amnesty International.

Everything I write about I have witnessed or experienced. Many of my audience are mental patients, including myself, who spent a few months in a facility in California at one point in my life.

Turning to *Guilty Guilty Guilty*, it is another exemplary song cycle. However, compared to *Defixiones* and *Songs of Exile*, what it appears to lack is an overarching political, as opposed to musical, philosophy. Has it proven necessary to balance particularly challenging works with (by your standard) crowd pleasers?

When you have 1,000 colours to choose from and you only choose fifty it is then, and especially then, that you should be suspected of larceny. *Guilty Guilty Guilty* has absolutely nothing to do with politics. It is a record of love songs, including the love of the Grim Reaper for the flesh of the human body, and the cries at the grave of the wife of a dead soldier. I am not living in a monastery. I have a love life. I sing love songs like any other Greek, who also sings political songs.

I am surprised you have not tackled the War on Terror and 9/11 more directly in your work, especially as those clamouring for war are not speaking in metaphors!

It is not my job. Why don't YOU do it? The subject bores me to death. America had it coming.

A classically trained friend of mine who attended one of your concerts observed that you play the piano like a guitar. He observed that you bend the notes: "If she could bend the keys she would do so."

He is absolutely correct. I play the piano as a piano, as the drums, and as a string instrument tonally so that it will emulate the music I am attempting to get out of a tonally digital, rather than analogue, instrument.

How far is improvisation a factor in these covers?

I am an improviser and have been since I was seven years old. I improvise with my voice and the piano at all times, as any first rate musician does, within the constraints that may or may not be imposed by myself or the composer whose work I interpret.

Could you tell me how a text of yours came to be read out by [expert on genocide studies] Desmond Fernandes, outside, then inside, the House of Commons? This was for the memorial of the murder of Hrant Dink, editor-in-chief of *Agos* [Armenian-language newspaper in Istanbul].

My commitment to the Anatolian Genocides has been noted by many scholars and artists, and I am asked to comment during important events. I do so when I feel it is appropriate and have the time.

Has it got easier or harder to make challenging music of the type you produce?

Why would it be easier to produce challenging music. That is an oxymoron.

Are there any future projects on which you plan to work?

I should certainly hope so. However, I don't like to talk about work I am doing currently. Occasionally I do it, but only if those are the only questions in an interview.

NOTE One half of the above interview was conducted face to face and, due to time constraints, the rest was conducted via email. The change in Ms Galás' tone marks the difference between the two.

||

Bangkok Blowjob Bars.

by Peter Sideway

BANGKOK IS the rapidly expanding capital of Thailand. Tourists flock to the city each year, as do illegal immigrants and enterprising businessmen, all eager to exploit new markets in Southeast Asia and see the sights. PETER SIDEWAY found the blowjob bars.

WE STOPPED off in Bangkok for forty eight hours before making our own way to the islands. The temptation of visiting Patpong, with its famous go-go bars and girlie shows, was too much to resist.

Picture, if you will, The *Deer Hunter*: US soldiers resting and recovering from their napalm baptisms in the south east Asian jungles of yesteryear, the image slowly dissipating into the sour reality of the now tourist infested Patpong. The emotionally vulnerable mothers, sisters, aunts and daughters who offered themselves to any passing GI have been replaced by the bright night market selling fake watches, t-shirts, jeans, jewellery and CDs.

Along the narrow streets vendors jostle the titillated tourists, while touts tug eagerly at sleeves to offer "sexy movie" or ping-pong shows. The "hello" girls pose dispassionately outside the stylishly dilapidated go-go establishments, beguiling the guileless. Inside, g-string clad girls vacuously go through the motions of the "buffalo shuffle" on a stage to some Asian eurotrance hybrid.

The first time I visited this part of the world I spent an evening in one of the King's Castle A Go-Gos, transfixed by the gorgeous girls, willingly complying with their endless requests for "lady-drinks". My testosterone fuelled illusions were cruelly shattered when I was informed that fifty percent of these girls weren't girls but ladyboys, including the one wrapped elegantly around me. He/she found it most amusing. Nothing in this city of vice is as it seems and even the humans here can be good fakes.

I waded with a friend through the night markets, hands heavy with newly acquired bargain shirts, stopping to take the obligatory photograph of a street vendor beaming behind his barrow of edible fried grasshoppers. Humidity caused sweat to pump from our pores as we scanned the buildings looking for the Rose, a place I'd heard about. The street heaved with tourist bars and Viagra peddling pharmacies plying their trade to the bloated Adonis' of yesterday seeking their erectile lifeboat. Eventually, having pleaded with a few touts for directions, we found Rose behind a common door, wooden and dirty. All that was missing was a letterbox. The sentry on duty pressed a buzzer to alert the occupants. The door opened and we were ushered in.

Climbing the narrow staircase our eyes adjusted to the semi-darkness. The smell of incense seductively, almost successfully, concealed the malingering odour of legions that climbed these stairs before us. We entered a small room bathed by a naked red bulb. Unsightly fitted chairs uniformly lined the walls, facing an empty stage that waited patiently for some activity. Silhouetted behind the bar lurked the only other male in the establishment.

This is a blowjob bar. The concept fascinates me. I try and imagine the Wagon and Horses, my local back home, as a similar establishment.

A gaggle of eager female types welcomed us into this den, aged in their twenties or mid-thirties, and wearing rather unfetching outdated bikinis. Some girls are fairly pretty, others are downright scary. Strangely some wear black tights under their bikini bottoms. Two of the more appealing girls take us to a table and sit down on either side of us. Behind our seats, stacked high against the wall, is a tower of toilet rolls; a reality check.

"Where you from?" ask our cut priced concubines.

"England," we reply.

"Do you want blowjob?"

Their hands dive between our legs squeezing our groins. My attempt to explain the concept of window shopping remains stubbornly unspoken in my throat. Instead I find myself requesting prices for aforementioned services.

"700 baht."

During this blunt conversation another western guy enters the room and sits opposite. Within seconds two girls are kneeling between his legs taking it in turns. Relaxed and well dressed he doesn't look much like a tourist. I assume he is an ex-pat regular, maybe working here in banking. I guess that's the type of work an ex-pat does in Bangkok. The city gives the impression of wealth and business, with its modern skywise tower blocks, overhead highways, super speed railways and advertisements the size of football pitches.

My consort casually informs me that so far today she has given seven blow-jobs. Unsure what to make of this information I tell her I am thinking of travel-ling on to Cambodia, whereupon she offers her service as a tour guide; appar-ently she is Cambodian not Thai. I consider the benefits of taking up this offer but politely refuse. Her attitude towards me stiffens and she announces curtly she doesn't like the English anyway because they always want to poke her in the arse.

We finish our beer, thank the girls (who decline to pose for a photo) and grudgingly make our way back down the narrow staircase into the street.

Later, as I wait in King's Castle 2 a Go-Go for my friend to return from his "short-time" with a particularly tasty dancer, a blowjob in the Rose suddenly seems like a missed opportunity...

The girls seemed to be expecting us as we emerged again at the top of the dingy stairs of the Rose. How often they must see the timorous enter and leave, only to return with their Dutch courage armour.

We ordered more beers. I asked if I could have a blowjob but I wasn't keen to have it in public. I needn't have worried. For those like me who feel the pres-sure of performing in public there was a room barely big enough to fit the sin-gle bed that occupied it. It felt worn, used. I realized that one or two of the girls

probably lived here and worked from home. I took no chances so requested a condom and then thought better of it. I lay numb in a semi-drunken haze as the girl gave me what I'd come for, a filthy erotic bliss that was momentarily shattered whenever I opened my eyes to see Ricky Martin with his canine grin laughing at me from a dog eared poster.

The deed complete and dues paid we returned to the bar.

"That was quick!" my friend exclaimed.

A YEAR and a half later I am back in Bangkok, no longer the startled tourist but the knowing resident. The heat and the city's chaotic streets are not so overwhelming to me now, and my friends (the ex-pats) are an odd assortment of miscreant misfits who fit right in: English teachers with fake degrees, well travelled con artists, and musicians scraping a living from nightly perform- ances in the many bars.

During one lazy rainy season lunchtime, having abandoned work for the day, I was enjoying cheap beer with two friends. Our quick post-work drink became a full blown drinking marathon and the relatively sedate atmosphere of the Bobby's Arms soon bored us. As we were near Patpong, we decided to check out the sleaziest bars we can find.

First, the Star of Light, another blowjob bar. Girls sit around tables outside, eating noodle soup, chatting idly, and occasionally tempting a hapless tourist into their den. A buzzer announces our arrival and a couple of the girls stop their chatter to follow us into the compact interior. We settle ourselves at one of the larger seats, girls strategically placed between us. Thankfully there is only one other customer sharing the oppressively small space and he isn't be- ing blown. The girls immediately start the familiar groin squeeze and ask if we would like blowjobs. To their apparent disappointment we panic, decline and sheepishly order more beer.

Running along one side of the room is the bar with its notorious, curtained glory holes cut into it, for which the place is famous. Whilst serving a cool la-

Long Gun girl

ger, the barperson can discreetly crouch down and suck away. One regular gets his kicks by proudly standing at the end of the bar whilst being given a hand-job and seeing how far he can ejaculate. I'd heard many a sordid tale about this place but the afternoon of our visit was rather tame. The evenings we were told were full on orgies and much better.

Patpong is not the only place in Bangkok where one can indulge. Nana Pla-za, a vast open space surrounded by three floors of go-go bars, drips with dirty decadence. It's here that the tired, bloated ex-pat punters can obsess about the perverted paradise bars. A couple of years ago, the story goes, one ex-pat had his ashes brought to Nana for a final trip to his favourite bars.

For me, Nana Plaza is summed up by two things: One of these is the sight of a very fat guy whose trousers fall down in the middle of the road; one of the two newly acquired girls on his arm unsuccessfully attempts to pull them back up to the cheers of the on-lookers. The other thing is seeing a girl squeal with disgust when she accidentally steps on a large rat, which convulses until finally being squashed to a bloody mess by other unsuspecting patrons.

The plaza sprang up around the notorious Nana Hotel where battle weary GIs once sought cheap respite from the bloodlust jungles of Vietnam. The hotel is now a favourite with sex tourists from every orifice of the world. The ground floor houses the famous Angels disco, where sweating septuagenarians fill the dance floor, body gurning to banging techno as their pacemakers uneasily rep-licate the beat.

How many ungentlemen have found their Viagra induced erectile euphoria slowly eroded by the fear of inevitable flaccidity and impending death? It is fitting that many of these amorous ambassadors should fall to the floor of a place called Angels, clutching their chests. Thais are superstitious people and rumours run rife that the ghosts of the recently deceased still trawl the hotel corridors for their perverted kicks.

The road leading away from the Nana is known locally as the "the goat track". More commonly known as Sukhumvit Road, it is the rat run through this part of Bangkok. At one am, the bars close and the myriad stalls mirac-ulously morph into cheap tables, cheap chairs and even cheaper prostitutes.

Captivating ladyboy pickpockets elegantly ply their trade as raggedy children sell dusty flowers and the drunk stumble blindly towards an uncertain fate. Chang beer continues to flow until beer blisters develop on your brain and beer goggles entice into taking your pick from the willing girls. At six am the dustcart arrives to clear the drunken detritus, the road returns to its daytime activities and the cycle begins again.

Soi 13, on the corner of a small lane that leads off Sukhumvit, is where you find the old timers, the worn faced westerners who sit around tables drinking and whoring away their pensions. Some wear neon dyed hair or ill fitting wigs in a desperate attempt to hold onto their long lost youth. Others have run away from financial debts back home or the wife and kids. If you're lucky you may meet a friend from my apartment block who regularly sits at one of these tables. Now in his late fifties, he arrived twenty or so years ago via India where he worked as a geologist. A true rogue through and through, his life revolves around Soi 13 and the hookers he obtains for the lowest price — even taking them home on the back of his pushbike. He has kept a diary of every girl he's had, which is now over 2000, all without a condom. Amazingly he isn't HIV+ but he does suffer from the paranoia brought on by his self-published science fiction novel, which involves Buddha. This was back in 1992. One night while asleep in bed, shortly after the book was printed, the police kicked open the door to his apartment and shot him. He believes that in writing his book he angered supernatural forces and now refuses to have anything to do with it. The book never made it to the shops and all the remaining copies are slowly being eaten away by the red ants in his run-down apartment. The photo on the back of a once handsome man slowly disintegrates in a city that only appreciates what's "new", MTV and the size of your wallet.

Further down Sukhumvit, you are assaulted by Asok junction. Green and yellow taxis, battered lorries from the provinces, open-back pickup trucks full of Burmese and Cambodian construction workers wait at the lights as tourists and food sellers with carts race across while the green man flashes. Suddenly the lights change and with a revving of engines the traffic moves off in a rising

haze of exhaust fumes, regardless if you are halfway across or not, narrowly avoiding the vehicles that have jumped the red lights on the other side.

Leading off this junction is Soi Cowboy. This is the other naughty nightlife area. It is a small road with go-go bars running along either side and is named after Cowboy, a US soldier who returned from the Vietnam War to open a bar there. The bars are generally smaller than the more glitzy ones in the other areas, but this hasn't stopped it becoming the favourite hang-out for ex-pats.

Neon bar signs protrude from the old converted storefronts: Long Gun, Spice Girls, Dollshouse, Suzie Wongs. Here the girls are less mercenary and the drinks are even cheaper. Groups of guys wander the street trying to decide which bar to enter while "hello girls" or groups of go-go dancers between shifts, dressed in bathrobes and thigh length boots, try to entice them into their bars. Amongst this bizarre milieu a lone young elephant would walk with its two owners, encouraging tourists to buy some food to feed it, while the girls nervously dodged its exploring trunk.

Above the go-gos is where many of the girls live, eight or nine in a single room. If you know where to look, you can find the equivalent of the infamous ping-pong ball shows. Here one may watch girls smoke cigarettes, play toy trumpets, blow out candles on a birthday cake or fire darts at balloons hanging from the ceiling above your head. They are not using their mouths. Japanese men put on their glasses and tilt their heads to take a closer look at the action that is taking place two feet from their face. They inquisitively study the performance as if they were watching an opera or poetry reading.

My favourite toilet in Bangkok can be found here. It is basically the girl's dressing room with a urinal running along one wall. Whilst peeing you can watch the topless girls applying makeup in the mirror and if you're really lucky you can exit the toilet as one shift of naked girls leaves the stage and squeezes past.

My apartment was close to Soi Cowboy and on the evenings when I wasn't feeling too adventurous I would stroll down there for a relaxing drink. I often found myself barflying at the After Skool Bar where the girls all sport fantasy classic school uniforms or French maid outfits.

At seven in the evening at the After Skool, the girls are herded onto the stage by the elderly Austrian manager who proceeds to inspect them like soldiers, usually accompanied by the cheerful tones of Boney M or the like.

This isn't really a blowjob bar as such, it is known as a "diddling bar". Here the girls swarm around you, asking for drinks whilst groping you, and you them, hence "to diddle". Their objective is to get you to go into "the Naughty Boys' Corner", which is a stool at the far end of the bar, designated with a wooden sign above. Here you are given a hand-job, or blowjob.

This is a good bar to people-watch — that is, if you don't mind seeing an aged, overweight "naughty boy" having a couple of girls working on him at once, while another waves a hand fan to keep him cool.

I recall a Benny Hill look-alike regularly positioned at the bar, who liked girls to remove their underwear and dance for him. Bending them over he would coldly insert a bony finger then greedily suck his fingers.

One evening a gorgeous girl told me she lived with her westerner boyfriend who supported her financially. She no longer worked the bars but enjoyed visiting the girls, who fondled her breasts and squealed excitedly. She explained that salt water surgery on her breasts made them interesting to the other girls, and sexier, i.e. larger. She pulled down her top to reveal this new sexy look and allowed the girls to twist and tweak until a new found sense of decency compelled her to cover up.

The Naughty Boy's Corner haunted me. *Dare I?*

I sat expectantly in the bar when suddenly Dew, an employee I had chatted with a few times, arrived for work and was surprised to see me. She changed into her schoolgirl uniform and asked if I wanted to go to the Naughty Boy's Corner. I looked down at the bar stool. How many sweaty arses had sat on this before mine, I thought as I pulled down my trousers and positioned myself. The girl behind the bar brought over a tub of Kleenex Wet Ones and placed it next to me. Dew grabbed my hand and put it up her shirt to reveal that she was braless. My other hand she slipped down her skirt into her underwear — wow, it felt good. She knelt before me, latched on and slowly began weaving her magic.

AROUND THE corner from Soi Cowboy used to be a small cluster of makeshift bars called Asok Plaza. These circled a gravel car park where sleeping dogs would lie in the hot dust and motorbike taxi drivers came to urinate. The bars reached as far as the Asok junction where one of my visiting friends from the UK spent the entire three weeks of his holiday, including Christmas Day and New Year's Day, breathing in the thick exhaust fumes — all because he'd fallen for the charms of a pretty girl in one of the open-air roadside bars. At the far end of the makeshift car park was a small bar called Lolitas. This too was a blowjob bar.

I felt as if I was in a cheap spaghetti Western as I swaggered across the gravel to the small wooden makeshift hut. The girls lounging on the porch seemed more attractive than usual and as I entered swarmed desperately around me, each promising a better blowjob than the others. I thanked them and implied I would give the matter consideration. A tantalisingly cute girl in tiny shorts followed me to the small bar, where a TV high in one corner of the room played a Thai karaoke VCD. Girls in bikinis sang to us dreamily against a paradise beach backdrop, the words helpfully bouncing across the bottom of the screen.

I ordered my beer and the lady serving it asked if I would like a blowjob. I replied "Yeah, okay, thanks" and was then taken by the young girl in tiny shorts to the back to some fitted leather seats, where she pulled a curtain around us both. The only other guy in the bar is secreted behind a curtain of his own, betrayed by the rhythmic sound of sucking.

The girl is from Southern Thailand, which is unusual because most of the girls in the tourist orientated nightlife areas are from the province of Isaan in the North East of the country. Isaan is Thailand's largest and poorest province. Many of the girls have turned their backs on the long hours and low pay of the rice fields and factories, and migrated down to Bangkok or other tourist traps. Here in one night they can earn what they would make in two weeks. In a country where there is no welfare state, much of the money is sent home to help pay for the elderly parents or a son or daughter left from a broken marriage or ex-boyfriend who's either eloped or died in a motorbike accident.

The girl orders me to drop my trousers, which I do, and I sit down with beer in hand. She kneels between my legs and embarks on a blowjob as I casually sip my beer. After a long while she asks me to stand up so she can sit on the stool and continue. I feel like someone in a seventies French porn movie, standing over her with her head bobbing backwards and forwards, swigging my lager which should have been Champagne.

The end isn't in sight so I ask if I can sit back down.

"You not like my mouth?" she asks.

"Yes," I reply, "it's very good." Actually, her oral skills are amazing.

My mind keeps wandering back to the previous night's dance competition. These are a regular fixture on the Bangkok nightlife calendar, when a selection of go-go bars put forward their best dancers to compete for a hefty financial prize. Some dancers, usually the Long Gun girls, are very good; others just go for all out debauchery. My little death finally arrives, inspired by the sight of a girl lowering herself onto an upright Heineken bottle and then riding up and down. I pay my 700 baht and leave with an air of relaxed urgency in my gait.

The Asok Plaza bars are now long gone and another new shopping centre proudly testifies Bangkok's new found wealth.

~~~~~~~~~~~~~~~~~~~~~~

AFTER THE demise of Lolitas in Asok Plaza, the Australian owner moved to a new premise back up Sukhumvit Road, near Nana Plaza. Tucked away in a very small side street, the new establishment bears the same name, a tribute to the great Nabakov. The owner's successful brand of blowjob bar has really taken off. These are the best places to start for the novice blowjob bar visitor because privacy is assured and you are not likely to see anything too shocking. With the success of the Lolita brand new branches have opened in the seaside resorts of Hua Hin and Pattaya.

In Pattaya I sought out a venue called Nice as Ice. Here they have the unique trick of wrapping ice around your dick just as you are about to ejaculate

Nervously I approach the entrance. Outside are seated seven girls dressed in matching uniforms of short sleeved white shirts and short red tartan skirts. I walk to the door that is draped with black curtains and stick my head through. The bar is busy. I turn to walk away but the girls gently coax me into staying. I order my beer and the girl who comes to sit with me casually asks if I would like to go upstairs. She leads me with beer in hand through a door into a dimly lit room, and we push through a labyrinth of curtains until we arrive at a pvc sofa. One curtain opens and a girl and her sated customer depart. The lack of privacy between the curtains preys on my mind. The gulping and groaning fills my ears.

I remove my trousers and she kneels on a stool between my legs and blows me. She is an expert at her trade and I reach a rapid crescendo as she uses her entire body to thrust her head up and down.

Basking in an orgasmic afterglow, we sit at the bar and I coolly finish my beer.

"How many blowjobs have you given today?" I ask.

"You're the first," she replies.

She knows all the right answers. She tells me she's been working in blowjob bars for five years and has a young son living with her parents up country. I do not ask how many blowjobs she thinks she may have done in five years.

An assortment of handbags fills the sofa opposite.

"How many girls work here?"

"Fifteen," she says as the guys around the bar discuss the death of Evel Knievel.

~~~~~~~~~~~~~~~~~~~~~~~~~~~~

PAST ASOK Junction and further on down Sukhumvit Road is Washington Square.

In the day the square is typical, containing a variety of small businesses, where dispatch riders sit around eating noodles from the various food vendors and mechanics repair rusting pickup trucks from their roadside workshop. The

square is dominated by the Mambo theatre, a tall white building with a snooker hall below. Coach loads of Korean tourists descend here every night for the ladyboy cabaret shows. Blending subtly into the area is a different kind of Bangkok bar, one that caters to a devoted clique of aging regulars who staggered here in the seventies and never had the heart to leave. The developers wait for the reaper to clear them up so the bulldozers can wipe away another pocket of shameful old Bangkok and nurture the new, wealthy, progressive Bangkok.

On one side of the square is a small bar called Wild Country. On entry it's like any other bar in the square, but the true nature of this bar isn't obvious. A generic country and western tune lamely fills the air. A small shelf of trophies randomly stands behind the bar. Making my way across the room one of the girls joins me, grabs hold of my crotch and begins to gently massage it. I am encouraged to sit on the sofa at the far end of the room so the girls can go to work on me. Although known as a blowjob bar, Wild Country seems more a diddling bar than anything else, but blowjobs are on the menu. An Australian man with his grown-up son buys drinks for everyone, then dances with joy alone while his son looks on with the prettiest girl in the bar in his arms.

~~~~~~~~~~~~~~~~~~~~~~~~~~~

AND BACK to that October afternoon in Patpong when the rains were especially bad as my Canadian and Australian friends and I contemplated which sleazy bar to try next. The week before I had to wade up to my knees in dirty water to get to work and scores of cockroaches jumped onto me in a desperate plight to save themselves from drowning. A return visit to the Rose seemed a good choice. We entered and climbed a steep staircase and I found myself once again in the small dimly lit joint.

The girls hadn't improved much. The better looking ones were in early seventies style bikinis and the ugly ones wore cocktail dresses. One was about sixty five years old and could have walked straight out of a John Waters movie.

No time was wasted in asking the inevitable question but we only wanted beer. Some of the girls were Cambodian, so my friend handed them a copy of a

CD of Cambodian sixties garage bands, *Cambodian Rocks*. They agreed to play it and played it loud, the burning incense underscored the vibe. It was good to hear the sound of fuzz guitars and Farfisa organs filling the place. Occasionally the girl in the bikini sang along with the CD while doing a sixties style dance. She repeatedly asked if we would like to go into the small room. The old lady occasionally came over to manically sing a chorus before asking if we would like to buy some *yaa baa*. (These are methamphetamine tablets. This was prior to then prime minister Thaksin Shinawatra's 2003 War on Drugs, where 2,700 people were hunted down and extra-judicially executed over a seven week period. In 2006, Thaksin was eventually removed from power in a bloodless military coup due to charges of corruption and nepotism. Human Rights Watch described Thaksin as "a human rights abuser of the worst kind". He has recently been living in exile in the UK and is currently the owner of Manchester City Football Club.)

The CD began to skip and stutter and was replaced with the obligatory trance-pap as the two better looking girls stripped naked and danced on the small stage. We left grateful that the old lady remained clothed and dignified.

▲

Badly dubbed Spanish/Italian/
German movie, 'Soho Franken-
stein' with gaudy Eastman col-
our Piccadilly Circus and Tra-
falgar Square, red bus litten
London red telephone box mur-
ders — the masked killer watch-
es to snatches of Shadows-like
music — it is a fabled Ger-
man land of Soho Frankenstein,
Edgar Wallace, peek-a-boo bras,
tasselled panties and fetish-
tic stockings — the disfigured
genius behind the mask of wax
watches his features melt into
'Anthony Balch Presents' — an-
other night of double-bills at
Jacey's, Piccadilly, London,
England, or was it a Franco
monster movie at the Stamford
Hill Odeon with scratched film
stock and badly dubbed soft
porn? — You paid twenty pence
for a European afternoon of
spangles, Inca cola, bad choco-
late, painfully recent circum-
cised masturbation and cinemat-
ic porn and horror continental
style. Later that evening, you
heard Michael Reeves had died.
('Films & Filming,' Oct. 1969.)

▲

...Judex and Edith Scob with
the figure of a man with a
bird's head in a doorway.
Light behind as Franju di-
rects towards a corridor amid
a series of doorways and win-
dows.

● ● ● ● ● ● ● ● ● ● ● ● ● ● ● ● ● ● ● ● ●

**NOTE** I received copies of *The Best of
Filmshow 1960* and *Target of Horror* over
ten years ago. The author and compiler was
MARK FARRELLY, a gentleman with a
particular fondness for the films of Michael
Reeves and Robert Fuest. I never met Mark,
spoke with him only once on the phone and
lost touch almost immediately. On January
9, 2008, I walked into a bar in the West End
of London with notes in my pocket per-
taining to *The Best of Filmshow 1960* and
*Target of Horror*, books I hadn't looked at
in almost a decade. At the bar I was intro-
duced to a mutual acquaintance, someone
called "Mark." Of course my mind turned
immediately to the notes in my pocket and
the elusive Farrelly. "Are you Mark *Far-
relly*?" I asked, preparing myself for some
weird synchronicity. "No," said the Mark in
front of me. [David Kerekes] ■

# Interview with Nuns.

## by David Kerekes

THE NUNS are an all-lady six piece band from London who love the Monks and play their songs. Headpress caught them at the DIRTY WATER CLUB on March 1, 2008, following their excellent set.

HEADPRESS: Are you all Monks fans?

BANJO DEBBIE: That's the entire point.

HEADPRESS: The Monks' music is so aggressive.

ANDREA: You need aggressive music, you need gentle music. They tried touring and people hated them. It's like the Velvet Underground — now that we adore them we can't imagine them playing shit towns and tiny dancehalls.

BONGO DEBBIE: They influenced so many bands, even by osmosis.

HEADPRESS: But when you think of a covers band you think of anybody but the Monks.

BANJO DEBBIE: I've not seen an Echo-belly tribute band... The Monks rarely wrote simple song structures: Instead of four-beats to the bar and four-bars and then a middle-eight, it'd be eight-beats to a bar and fuckin' seventeen-bars.

ANDREA: I Hate You!, for instance, everything goes on and on and it's painful. *Change now!* No. More bars keep coming. *It's gotta change now!* No, keep going. They've gone beyond the pain barrier and they keep going. No, keep going.

KATE: That's why people don't cover Monks songs.

DELIA: There's too much counting.

BANJO DEBBIE: Talk about your guitar business.

DELIA: I don't do anything. I've got my eyes shut!

HEADPRESS: Strange music for strange times.

ALL: *Strange music for any time!*

LINEUP: Banjo Debbie Nun *banjo*; Bongo Debbie Nun *drums*; Granny Andrea O'Saintly Bells *organ*; Sister Lolo Of The Five Wounds *singing*; Kate Kannibal (but only of the saved) *bass*; Delia Divinity *guitar*
www.myspace.com/itsnuntime

# "It's the Silliest Party of the Year... and You're All Invited!"

## by Scott Stine

MAD MONSTER PARTY? (1967) is a claymation feature film for kids by filmmakers Rankin & Bass that has achieved a richly deserved cult status.

PARODIES OF the classic screen monsters had become immensely marketable by the mid sixties; everything from Bobby "Boris" Pickett's top forty hit The Monster Mash to prime time television's *The Addams Family* to Topp's enduring *Monster Laffs* trading cards attest to the steadily growing interest. Although Dracula and the Wolfman had lost most of their bite, these and other enduring bogeymen had become popular not just with children but also with teens, thus monsters became peripherally associated with the growing counterculture. America's disenfranchised youth were drawn to such fictional outcasts, even going so far as to embrace the label of "freaks" in order to separate themselves from the more conservative generations.

The first real "monster" effort of Arthur Rankin and Jules Bass was the Saturday morning cartoon *The King Kong Show* (1966). Produced for ABC it never made it to a second season. This half hour program included two eight-minute episodes of "King Kong" and one of "Tom of T.H.U.M.B." In the titular cartoons, a precocious boy, Billy Bond, befriends the oversized ape and the two fend off various human villains who threaten their remote island hideaway.

For character design, Videocraft International hired Jack Davis, whom many fans know for his work with EC Comics: *The Haunt of Fear*, et al. The animation itself was produced by Toei Company, Ltd., the Japanese studio that brought us the Gamera films.

# MAD MONSTER PARTY?

This short lived Saturday morning series was responsible for Rankin & Bass' involvement with the theatrical film *Kingukongu no Gyakushu* (1967) aka *King Kong Escapes*, produced by Toei's rivals Toho Studios. Like *The King Kong Show*, this live action Japanese-American co-production displayed all of Toho's tell-tale earmarks, but few of Rankin & Bass'. Obviously, the studio's intentions were to cash in on theatrical release of Peter Jackson's epic remake of *King Kong*, which premiered during the same holiday season.

Rankin & Bass' foremost creature feature, *Mad Monster Party?*, was produced the same year. With artist Jack Davis, fellow EC writer Harvey Kurtzman and such gifted voice actors as Allen Swift on board, Rankin & Bass also employed the talents of aging horror veteran Boris Karloff. This was Rankin & Bass' third outing with Embassy Pictures and Executive Producer Joseph E. Levine, whom was struggling to make it in the family market and realized Videocraft could be his ticket. Levine's résumé includes everything from Italian sword & sandal epics to adult dramas to the granddaddy of all *kaijū eiga* films, *Kaijū o Gojira* (1966) aka *Godzilla, King of the Monsters!* Unfortunately, *Mad Monster Party?* was the third outing in a three-picture deal made between Levine and Videocraft in 1965; reportedly, the producer was disappointed with the receipts from the film *The Daydreamer* (1966) and thus didn't give the other two films the promotion they needed in order to be successful at the box office, despite the modest critical acclaim it accrued.

MAD MONSTER PARTY? (1967)

Embassy Pictures Corporation [US] Videocraft International [US]

DIR Jules Bass, PRO Arthur Rankin, Jr., SCR Len Korobkin and Harvey Kurtzman, DOP Tad Mochinaga, EXP Joseph E. Levine, MUS Maury Laws, SND *Mad Monster Party?* [Retrograde Records; CD], STR Phyllis Ada Driver (aka Phyllis Diller), Ethel Ennis, Gale Garnett, William Henry Pratt (aka Boris Karloff) and Allen Swift.

AKA: *La Fiesta de los Monstruos* [The Party of the Monsters]

Approximately 95m; Color; Unrated

Scott Stine is the author of *Trashfiend: Disposable Horror Culture from the 1960s & 1970s*, published October 2008 by Headpress

119

|||||||||||||||||||||||||||||||||||||||||||||||||||||||||||||||||||||||||||||

# Panther Burns and Howls.

## by Joe Ambrose

*Talking to TAV FALCO of the PANTHER BURNS about
strange business in Memphis.*

I FIRST met Tav Falco, leader of the Panther Burns faction, when, ten years
ago, we both participated in a Madrid poetics festival, Festimad. Lydia Lunch,
Richard Hell, the Master Musicians of Joujouka, Alex Garcia Alix, Hamri the
Painter of Morocco, John Cale, and John Giorno were amongst the powerful
creative people involved. We were treated to imperial paella in this large flam-
boyant dining hall in the city's venerable old art school where, I think, Dalí and
Picasso once hung out. A sexy young Zapatista stirred us in Spanish.

I have strong memories of going to see a definitive Goya exhibition at the
Prado with Richard Hell, of Tav roaming in search of tango parlours, of break-
fasting with Lydia, and of Hell looking for a real bullfight to go to. I met some
remarkably chic women with Tav; hanging out with him suggested to me that
others were leading more adult lives than I was.

In Madrid Tav performed solo but mostly, musically, he travels in style
with his Panther Burns combo. They bring the swamp into the existential-
ist city. Once I attended a hugely significant evening of his movies at Lon-
don's Horse Hospital. A onetime associate of America's best photographer
William Eggleston, Tav, with all manner of cameras, roamed the Southern
backwoods, neon cities, and swamplands in search of the real thing. The

film I liked the most was the one he shot about the pandemonium outside Graceland in the hours after Elvis' death. So much excitement about the fourth best act on Sun.

One more recent day I walked with Tav north from Maison Berteaux in Soho up Charing Cross Road past the eighties Marquee Club where I saw Jane's Addiction do their London showcase show. We'd been talking about our mothers and about our film ambitions. I asked him if he had any good stories for my *Chelsea Hotel Manhattan* book that I was then working on. [Published this year by Headpress.] He told me that he remembered one incident, which happened during Panther Burns' New York period which didn't actually have anything to do with the Chelsea Hotel but which should have had.

One night he and angry wild Jeffrey Lee Pierce from the Gun Club wandered through the Lower East Side, each of them balancing a foam mattress on his head, African-woman-carrying-water style, looking for a derelict abandoned house where they could throw their mattresses down on the floor and sleep for the night.

I thought it was a superb almost filmic image of romantic, youthful, rebellion, and a slice out of the life of any working artist.

I consider Tav to be one of the most significant American presences of our time and Panther Burns to exemplify that part of rock'n'roll which is touched by, reflective of, and in competition with, high art.

Last week I asked Tav what Panther Burns stand for and this is what he told me:

*It is the song of sex and death sung always in the Delta, and it's the same song with a more lyrical lilt sung up in the hills that eventually comes up river or down river into Memphis. The same song catching the wind off the side of a boxcar or drifting into town on the black wave of a river barge or floating on the winding smoke of burning mansions. The song of sex and death sung by a steppin' dandy with the bible in one hand and corn whiskey in the other. Sanctified in the*

*church or sung in the juke joint... the ethereal song of earth and sun, of loss and betrayal, of night and sacrifice. It is the song of the Panther Burns.*

*During the later part of 1978 at the time we were forming our group in Memphis, I kept hearing this word, this term, spoken around me, 'Panther Burn', 'Panther Burn'. Who is it? What is it, I wondered. Then I found out. It's a place. Panther Burn plantation off of Highway 61 just north of Greenville, Mississippi. A legend surrounds the plantation wherein at the turn of the century before last a wild cat, a tail dragger, a black panther, the last vestige of the vanishing frontier, displaced from forest and plain, homeless in the wake of further expanding cultivation of farmlands... the animal, out of a sense of hunger and general discontent began to howl all night, to harass the countryside, and to raid the chicken coops of the local farmers. Fed up with this worrisome nuisance, the planters launched a campaign to rid themselves of this creature who slept all day and prowled all night. When they caught sight of it, they fired their rifles and tried vainly to shoot it, but the panther was fast and they always missed. Then they set traps, but the panther was cunning and it eluded their traps. One night, a posse of irate farmers managed to run the animal into a cane brake (a stand of wild cane bamboo growing) and then they set the cane on fire. The shrieks and howls of the panther perishing within the flames were so horrific that the place became known from then on as Panther Burn. My cohorts and I thought this would be a fitting nom de guerre for a RnR band.*

*In New York, Panther Burns recorded a disc at Radio City Music Hall for Chris Stein's label, Animal. This was a subsidiary of Chrysalis, and in those offices one day I met Iggy who was also releasing a record on the label. The Animal connection resulted from our appearances on TV Party, which was a makeshift, videotronic cabaret cablecast out of studios on 23rd. St. and hosted by Glenn O'Brien and produced by Chris Stein. Other TV Party scenesters released by or connected with*

*Animal were Walter Steading, the electro violinist protégé of Andy Warhol, James Chance, Anya Phillips, Gun Club, Fast Phreddie, etc.*

Right now Tav is working with Erik Morse on a book. It'll be called *Death in Memphis*. This, Tav tells me, is what the book is about:

*Categorically, the roadside ghosts and highway spectres Erik Morse and I are pondering for our forthcoming book include the following shades and geists:*

**The Harp Brothers** *(circa 1770–Jan 1804) operated in Tennessee, Kentucky and Illinois. Unlike most outlaws, their crimes were motivated more by bloodlust than financial gain. As such, some identify them as the nation's first true "serial killers". The Harpes made no discrimination between age and sex in their victims, often butchering anyone under the slightest provocation including babies.*

**Fort Pillow Massacre** *was fought on April 12, 1864, at Fort Pillow on the Mississippi River about forty miles north of Memphis, during the American Civil War. The battle has caused great controversy about whether a massacre of surrendered African-American troops was conducted or condoned by Confederate Major General Nathan Bedford Forrest. Military historian David J Eicher concluded, "Fort Pillow marked one of the bleakest, saddest events of American military history."*

**Machine Gun Kelly**. *Memphis reared bank robber and foiled kidnapper known for urinating on G-men.*

**Johnny Ace** *had been performing at the City Auditorium in Houston, Texas on Christmas 1954. During a break between sets, high on angel dust (PCP) Ace allegedly decided to play a game of Russian roulette.*

*He aimed a .45 calibre revolver at his girlfriend, Olivia Gibbs, and pulled the trigger. He then attempted to shoot her friend, Mary Carter. Both times, the hammer fell on an empty chamber. He then swiftly turned the gun on himself and ended his life.*

***George Howard Putt**, sentenced to 497 years in prison in 1973 for a one-man crime wave that left the Memphis area gripped in fear as five people were stabbed or strangled and in some cases sexually mutilated with scissors. "He was unmerciful on his victims."*

***Dwite Jordan**, gifted black painter and a friend who had studied with Diego Rivera was shot point blank through the head in Memphis by the ex-con brother of his white go-go dancer girlfriend.*

***Lee Baker**, original guitarist with Jim Dickinson's band, Mudboy and the Neutrons, and accompanist of blues master Furry Lewis, shot to death in his home on the outskirts of Memphis by neighbouring black youths who then set the house afire with Lee and his aunt inside.*

***West Memphis 3**. Young boys were found hogtied and dead in a drainage ditch. The juveniles had been sodomized and emasculated by knife wounds and ritualistic animal predation.*

NEXT PAGE: Tav Falco on Broadway

||||||||||||||||||||||||||||||||||||||||||||||||||||||||||||||||||||||||

# A Guide to Unpopular Culture.

Reviews by
Ganymede Foley [GF], David Kerekes [DK],
Stephen Sennitt [SS] & Joe Scott Wilson [JSW]

## MUSIC

RASPUTINA
Oh Perilous World
CD Filthy Bonnet + Live: The Windmill, Brixton, January 28, 2008

WITCHCRAFT
The Alchemist
CD Rise Above

PREGNANT RAINBOWS FOR COLOURBLIND DREAMERS
The Essence of Swedish Progressive Music 1967-1979
Various Artists
CD box  ISBN 9789189136427  Premium Publishing 2007
www.premiumpublishing.com

■ The latest album from RASPUTINA, *Oh Perilous World*, draws on sources that don't exist (The Pitcairnian Women's Choir get a credit) to lyrics inspired by keywords tapped into Google. It's the soundtrack for a fictitious musical adaptation of a prize-winning book that is pure fabrication, and if that sounds like a mighty dose of affectation for a band comprising two cellos and a drummer, well, it is, but it works beautifully. The nature of art is to be a lie and Rasputina are very good at it. Their gig at the Windmill was proof enough of how rocking they can be (even when jetlagged) and the first opportunity for the British public to catch Rasputina play a small pub in Brixton. They rhyme the word "thunder" with "telephone number" (on A Retinue Of Moons/The Infidel Is Me) and that's a wonder, but not actually a part of the lyric. [JSW]

■ The music of Swedish band WITCHCRAFT used to be categorised as doom rock. On *The Alchemist* they play jagged guitars with sublime vocals that evoke the heavier noodlings of krautrock (notably My Solid Ground — so much so I can't hardly believe it). Witchcraft's Magnus Pelander sings of "thresholds" and how "clinging to this nothingness might do you good." I wouldn't call it nothing but very good indeed. [JSW]

■ *The Encyclopedia of Swedish Progressive Music* was a book published last year by Premium, which came with a free CD featuring one of the bands of the Swedish Progressive era (the rather dull Baby Grandmothers). From the same publishing house PREGNANT RAINBOWS FOR COLOURBLIND DREAM-ERS is a four CD box and a more satisfying and representational audio experi-ence, collecting seventy one of the hundreds of bands that never made it be-yond the Swedish border. Sweden is famous for sexual revolution in the 1960s. Music from Sweden didn't impact on the world in quite the same way, or at all, but is quirky and unique, flitting between jazz, rock and Zappa in his *Hot Rats* period. This is a great package of music that many listeners will not have heard before, presented with a lavish full colour book — so you needn't worry about the *Encyclopedia*. [GF]

# ART

THE GREAT MONSTER MAGAZINES
A Critical Study of the Black and White Publications, 1950s, 1960s and 1970s
Robert Michael "Bobb" Cotter
230pp  ISBN 798-0-7864-3389-6  McFarland & Co Inc. 2008

CLEAN CARTOONISTS' DIRTY DRAWINGS
Craig Yoe
£12.99 $19.95  160pp  pbk  ISBN 9780867196535  Last Gasp 2007
Distributed in the UK by Turnaround

SEX TO SEXTY: THE MOST VULGAR MAGAZINE EVER MADE!
Ed. Dian Hanson
420pp  hbk  ISBN 9783822852231  Taschen 2008

HOUSE
Josh Simmons
£8.99 $12.95  80pp  pbk  ISBN 9781560978558  Fantagraphics 2007
Distributed in the UK by Turnaround

HOTWIRE COMIX № 1
Ed. Glenn Head
£12.99 $19.95  136pp  pbk  ISBN 9781560977285  Fantagraphics 2006
Distributed in the UK by Turnaround

THE FUN NEVER STOPS! AN ANTHOLOGY OF COMIC ART 1991–2006
Drew Friedman
£10.99 $16.95  144pp  pbk  ISBN 9781560978404  Fantagraphics 2007
Distributed in the UK by Turnaround

THE MAMMOTH BOOK OF HORROR COMICS
Ed. Peter Normanton
£12.99  544pp  pbk  ISBN 9781845296414  Robinson 2008

■ I SO much wanted to like THE GREAT MONSTER MAGAZINES — and cynicism aside for a moment, not just because it set me back a staggering £35! No, it was much more because there have been so few books on the subject, and still fewer taking an overview similar to Cotter's.

Straight away then, I was amazed by the casual (best described as slack) tone of the book, which the author has deigned to subtitle a 'critical study'. All personal prejudice and snobbery aside, I for one would not have thought saying a certain magazine cover was 'neat', or 'cool' really showed the right sort of critical acumen one would have expected from the adoption of such a subtitle.

Similarly, the author has an irritating habit of overusing certain phrases, such as 'iconic status' and 'legendary', without giving any insights as to how he has arrived at these appraisals. Another problem is the repetition of the same information about a given publication, occasionally in the same paragraph! (This is especially apparent in Cotter's listings, just one example being the name checking of DC's *Doorway To Nightmare* in two mutually exclusive lists following on from one another).

Much more amateurish and problematic than any of the above though is the author's inability to decide between past and present tense in many passages, where the two are hopelessly mixed. (Perhaps his publisher could have helped in this department?)

In case I'm starting to sound picky to the point of pettiness, let me say that it is common to find these sort of mistakes occurring in fanzines, and other amateur publications, which seldom make any pretence to any real critical status.

Though somewhat regrettable, and occasionally groan inducing in the worst cases, fanzines are what they say they are, and such slackness is the prerogative of their editors and publishers. This should not be the case with a publisher like McFarland, who over the years has produced a list of genre books as important and groundbreaking as any other you would care to name.

However, this is not the only problem with Cotter's rushed and somewhat incoherent book. In a growth industry that takes pop culture more seriously than ever, perhaps sloppiness in style and execution can be forgiven if the majority of the information is sound and the facts are straight. But if this is not the case; what you have is a volume that leaves itself open to justified complaints.

Off the top of my head, not having made a list of any kind, here is a casual recollection of some of the errors that occur in only the first half of *The Great Monster Magazines*:

First off, Cotter quite sneeringly complains of a certain monster magazine's 'sloppiness' in miscaptioning a still from the Karloff film *The Ghoul*. He then goes on to make dozens of similar mistakes himself, such as calling one of EC's most famous horror comics *The Vault of Terror*, instead of *Horror*.

He calls *Castle of Frankenstein*'s famous correspondent Michel Parry, Michael Parry. He says Brian Lewis drew the *House of Hammer* adaptation of *Curse of the Werewolf* when it was John Bolton.

He says with great authority that George Torjussen painted only two covers for Atlas/Seaboard when he actually did three, the one Cotter misses being *Movie Monsters № 3*.

He praises Tom Sutton elsewhere in the book, but dismisses Sean Todd, not seeming to realise they are one and the the same person! (Sean Todd being Sutton's short-lived pseudonym for his early Skywald work.)

He says *Eerie № 66* is an all-reprint book when this is not the case — the Gonzalo Mayo-illustrated *El Cid* stories made their first appearance in this issue.

Cotter asserts that the 1974 *Psycho Yearbook* led onto Skywald producing All-original annuals, when in actuality these annuals appeared around two years previously to the *Yearbook*.

He also states in a discussion of Robert E. Howard's character Conan, that this was the most popular character to appear in the pulp magazine, *Weird Tales*. Anyone who knows anything about this legendary (oh God, now I'm at it!) publication will know this to be far from the truth; in its own day the magazine's most popular character was Seabury Quinn's occult detective Jules de Grandin (see Haining, *Terror! 200 years of Spine Chilling Illustrations from the Pulp Magazines*, 1976, p 83.)

And on... and on...

Cotter's inaccuracies are compounded by a lack of notes and references (as exemplified above), which often reduce his critique to unsubstantiated opinion. Even so, when he does supply some internal references to other chapters and passages in his own book, they are frequently inaccurate or confusing. For example, on page 125 we read the statement: *'See Chapter Four for more on Marvel's groundbreaking black-and-white title, and the Conan stories contained therein.'* What's the problem here, you might ask? Only that this statement referring the reader to Chapter Four appears in Chapter Four itself! There are similar muddles and errors with headings and subtitles throughout the book adding to the overall sense of confusion.

Are there any good things to say about *The Great Monster Magazines*...? As you would expect from McFarland, this is a very attractive hardbound volume, sporting a superb cover taken from Skywald's *Scream № 10*. It is nicely laid out with a good selection of cover images, all of them full-page size.

Cotter's inclusion of *Savage Sword of Conan* and other sword & sorcery and action/SF magazines into the study is a bold and much welcomed development on the monster/horror magazines theme, and for this innovation he is to be congratulated. Also his slight bias towards Marvel productions is interesting and refreshing, and he comes up with some sound reasons for valuing this company's titles as much as Warren's or Skywald's. However, yet again, often Cotter's decisions to privilege selected magazines with a capsule review seem too random, and he provides no real schemata as a guide to his reasoning and selection choices. All too often, one is given the impression that he has dipped

into his own collection and been satisfied with what has been to hand, and his comments are sometimes naïve or too subjective to be of any real worth.

In conclusion, Cotter has produced a very disappointing book. He lacks sufficient knowledge of his subject and the necessary skill to do that subject justice.

Ten years ago I wrote *Ghastly Terror! The Horrible Story of the Horror Comics* (Headpress, 1999), a book admittedly replete with its own mistakes, omissions and errors, but which has been recognised as something of a pioneering work due in no small part to the incredible scarcity of reference material available at that time. Ten years later, and with a plethora of books, magazines and web pages to draw upon that just didn't exist when I was writing my own contribution, authors of Cotter's status should have been able to produce a volume light-years ahead of my own. Sadly, this is not the case and instead the book takes one step forward and two back.

Fans and critics alike still await a book to do this fascinating subject its full justice. [SS]

■ Everyone knows the work of Dr Seuss, Charles Schulz, Al Capp, Jack Kirby, *et al.* Well, CLEAN CARTOONISTS' DIRTY DRAWINGS collects a whole bunch of artists better associated with wholesome gags, newspaper strips and superheroes and reveals a more salacious side to their work. This isn't to say pornographic drawings have been discovered in the bottom drawer of artist studios around the world, rather here is sexy stuff drawn for fun and profit, dirty images closer to burlesque than they are the grotesque. We have busty gals with stocking tops and cheeky skinny dippers of a kind that cause men in glasses to get all steamed up; nothing too risqué. [JSW]

■ In the late 1960s and 1970s there were quite a few "laffs" magazines on the news-stands. SEX TO SEXTY was one of the longer running ones, made from cartoons the sophisticated smut rags rejected. For this vast collection (which is up to Taschen's customarily high standard and includes a poster-size dustjacket of all the *Sex to Sexty* covers) the cartoons are collected thematically.

Even dipping into this stuff is hard work, unless you enjoy really dumb gags, millions of the fuckers. However, you may gasp at late sixties promiscuity that makes light of bestiality, rape and child abuse in a news-stand magazine. [GF]

■ A group of backpackers converge on an abandoned house in the middle of nowhere, and once inside cannot escape. It's not much of a story but Josh Simmons tells it well in HOUSE, a nicely rendered and bleakly evocative wordless picture story of doom. [GF]

■ HOTWIRE bills itself as a compilation of "comix and capers" by various artists. The lofty intention of editor Glenn Head is to put the fun back in comics. He laments the state of comics today but I'm confused because publisher Fantagraphics have been putting out a lot of great comics for years and Hotwire isn't one of the better ones. [JSW]

■ Daniel Clowes wrote the foreword to THE FUN NEVER STOPS! and his name has pride of place over that of the book's author/artist, Drew Friedman. I guess that's what happens when you write *Ghost World* and things like that, as Clowes did. Clowes is a good draftsman who deals with comtemporaneous matters in a knowing way. Friedman on the other hand draws as though he was born in 1922 and delivers work that is slavishly detailed (the way it was in the old days). He also uses characters like Frank Sinatra and Fred "Herman Munster" Gwynne as if they were the word on the street nowadays. Friedman is terrific. We love him. [DK]

■ The long running Mammoth series of books has covered over the years everything from great inventions through to women who kill (but not "mammoths", as Simon Collins noted in an early Headpress). The latest instalment is THE MAMMOTH BOOK OF HORROR COMICS, a collection of almost fifty strips, commencing with "Famous Tales of Terror" published in 1944 and concluding with "Shuteye" in 2004. The editor of the book is Peter Normanton, whose *Tales from the Tomb* magazine is a homage to the horror comics of yes-

teryear and has put him in excellent stead for this kind of work. The strips prior to 1980 in the first half of the book are the most appealing, with representatives of the pre-code era as well as Charlton and Skywald. (No EC, Warren, Marvel or DC, however.) After that, with a few exceptions, the horror comic loses its flair and essence of dementia and goes downhill. But this is a nice packet for all of that. [JSW]

# FILM

CINEMA SEWER
The Adults Only Guide to History's Sickest and Sexiest Movies!
Ed. Robin Bougie
£11.99 $19.95 191pp pbk ISBN 9781903254455 FAB Press 2007

CRAWLSPACE
Dir: John Newland, US 1972
DVD R1 Wild Eye

THE DEVIL'S DAUGHTER
Dir: Jeannot Szwarc, US 1973
DVD R1 Wild Eye
www.wildeyereleasing.com

■ The most striking thing about CINEMA SEWER is the handwritten layout of editor Robin Bougie. I've seen this done before in fanzines from years ago, which gives me the credibility and authority to write a top notch informed review. Bougie has a steady hand and tells us funny things about awful and demented films. This volume collects material from the early editions of Bougie's self published *Cinema Sewer* zine (Linda Lovelace, death videos, *Bumfights*, women raping men, *et al*), illustrated with one or two badly Xeroxed ad mats or a drawing, which adds to the general air of degeneracy. I give hardcore and handwriting my big thumbs up. [JSW]

■ The first two releases on the Wild Eye DVD label are vintage made for TV movies. CRAWLSPACE is about a young man with strange hair (Tom Happer), who attaches himself to a retired couple (Arthur Kennedy and Teresa Wright) after they loan him a book of verse by William Blake. They make him promise to bring it back, which he does, but he attaches himself to it and lives with the

book in the crawlspace of their cellar. The couple coax the young man out to listen to records, but soon enough wish they hadn't. The film is a backwards take on *Whistle Down The Wind* and curious enough to hold the attention, even if nothing much happens but an ambiguous sideway glance whenever a commercial break is due.

Wearing its inspiration on a very long sleeve, Wild Eye's second release THE DEVIL'S DAUGHTER is almost a carbon copy of *Rosemary's Baby* and, despite being five years too late, it's difficult to figure why no one from William Castle Productions came running with a writ when it aired. The film makes no effort to embellish the story of urban black magic and devil kin, but it does provide a little cheer on a rainy Sunday and the cast is great, especially Shelly Winters. [GF]

# PHILOSOPHY

COLIN WILSON: PHILOSOPHER OF OPTIMISM
Brad Spurgeon
£9.99 150pp  pbk  ISBN 9780955267208  Michael Butterworth 2006

ART THAT KILLS: A PANORAMIC PORTRAIT OF AESTHETIC TERRORISM 1984–2001
George Petros
$24.95 £16.95  320 pp  ISBN 1-84068-140-3  Creation Books 2008

■ *"One of my main problems as far as the public is concerned is that I've always been interested in too many things."* So says Colin Wilson, writer and philosopher, in COLIN WILSON: PHILOSOPHER OF OPTIMISM, a very entertaining book comprising one long conversational interview with Wilson conducted by Brad Spurgeon and some short essays. *"If they can't typecast you,"* Wilson adds, *"then I'm afraid you tend not to be understood at all."* [GF]

■ This is my personal favourite of recent releases: ART THAT KILLS: A PANORAMIC PORTRAIT OF AESTHETIC TERRORISM. I was lucky enough to get hold of a copy of last year's 'subscriber only' hardback, limited, signed edition, but this current printing in trade paperback format is actually better, benefiting from 'tweaking' here and there in terms of illustrations and photographs,

and in the inclusion of pieces on Kenneth Anger, Swans, Christian Death, and a few other notables strangely overlooked first time round.

Looking at this 'panoramic portrait' of the Aesthetic Terrorism movement has a paradoxical effect: I'm overwhelmed by a kind of nostalgia for something that hasn't actually ever gone away, yet is still very much too extreme to have been co-opted by the mainstream. What this book manages to communicate is a sense of incendiary excitement surrounding a group of disparately connected artists, writers and mad visionaries of the 1980s and 1990s that has perhaps somewhat dwindled in the intervening years, whilst never losing the original glaringly bright spark which could reignite the whole thing again at any moment.

No, the likes of Adam Parfrey, Death in June, Genesis P-Orridge, Boyd Rice, Michael Moynihan, James Havoc/Williamson, Jim Goad, Lydia Lunch, Joe Coleman, Mike Diana, sundry Satanists, pornographers, transgressive film makers, and a whole host of demons-in-human-form in various goth, black metal and 'industrial' bands are still very much with us! (And so too, more unfortunately, is that one-note wonder, Peter Sotos...)

It seems the vital spark that this book identifies so well between the years 1984–2001 was so fierce its afterglow has carried through to the present time, and doesn't seem to show any signs of diminishing as time runs rapidly amok towards the big crunch of 2012.

As I look through this book, identifying faces and figures I've known, corresponded with, written reviews about, I can hear my mother saying with disgust and consternation, 'I hope you're proud'!

The funny thing is, I am.

One of the strongest feelings communicating itself to the reader is the fact that good or bad, strange or just plain *mental*, the entities in this book have all made a lasting mark on sinister/'underground' culture, the repercussions of which are still being felt and developed upon by (perhaps less impressive but distinctly ever-present) younger generations of evil progeny. I feel proud to have been on the first wave; to have had the same instincts; to have experienced the times laid out in this book first hand.

*Art That Kills* is a brilliant chronicle of the lives and ideas of Prodigies, Monsters and Demons perhaps more talented, perhaps more deranged, perhaps more ambitious, than myself and yourself; similarly oriented, running on a parallel course to myself and yourself, some of them heading for death and damnation, some for complete obscurity, and some for rock mega-stardom, like Marilyn Manson.

What we all have in common – whether contributor, subject, or avid reader – is that here is a book which *belongs to us.* [SS]

## SAVOY

HORROR PANEGYRIC
Keith Seward
125pp  hbk  ISBN 9780861301188  Savoy Books 2008
www.savoy.abel.co.uk

■ Savoy, as any Headpress reader knows, is a Manchester based publishing house that was once highly commercial but increasingly doesn't give a hoot outside of making quality work that pleases them. They don't dally with cultural labels and cannot be categorised as a part of a publishing movement; the tide on which they sail flows neither with the mainstream nor with the counterculture. The Savoy publishing schedule of recent years has lost none of its eclecticism, as evidenced in the beautiful reprints of Maurice Richardson's *The Exploits of Engelbrecht* and David Lindsay's *A Voyage to Arcturus*, an unexpurgated edition of Colin Wilson's *The Killer* and new fiction in the shape of Lucy Swan's *The Adventures of Little Lou*. On top of it all Savoy have been propelling their own mythos with books devoted to themselves: Robert Meadley's *A Tea Dance at Savoy* (2003), DM Mitchell's *A Serious Life* (2004) and Jon Farmer's *Sieg Heil Iconographers* (2006), are all chronicles of the colourful and turbulent story of Savoy and its people, from early days with New English Library, being William Burroughs' UK publisher in 1979, working with PJ Proby in the 1980s, and beyond — interspersed with lashings of police harassment and busts.

The latest addition to this canon is Keith Seward's HORROR PANEGYRIC, which is an appraisal of the three Lord Horror novels, written by David Britton and published by Savoy. The first of these, *Lord Horror* (1989), was met with cries of anti-semitism and went to court as obscene. (It was eventually acquitted.) The other two novels, *Motherfuckers: The Auschwitz of Oz* (1996) and *Baptised in the Blood of Millions* (2000), follow Horror, his cohorts Meng & Ecker, and history's damned as they make their way through a universe that at times appears to be our own. The novels are unapologetic in what they show, do and say. Seward regards them in the same light as Arthur Rimbaud's poetry, William Burroughs' *Naked Lunch*, Samuel Beckett's trilogy (*Molloy*, *Malone Dies*, *The Unnameable*) and Michael Herr's *Dispatches*. They are high art, he says, masterpieces, particularly *Motherfuckers*. He makes a convincing case in a succinct thirty pages. The latter half of *Horror Panegyric* consists of extracts from the novels themselves, which is evocative and surreal with the turn of a great phrase. It would be nice to think that Seward may convert the casual reader to his way of thinking — to our way of thinking — but it's unlikely the book will even reach them on a physical plane. A great shame. *Horror Panegyric* is possibly no more no less just another record on the Savoy jukebox, created for us to play to us what we already know. One day when it's all over this stuff will be a lesson heard in school. [DK]

# FICTION

THE BEST OF 10 STORY BOOK
Ed. Chris Mikul
$22.00  337 pp  ISBN [none given]  Ramble House 2006

■ A couple of years ago there was a fad in occult circles for the more obscure 1920s weird mystery thrillers of Fu-Manchu creator, Sax Rohmer; titles such as *Bat-Wing*, *Brood of the Witch Queen*, *Grey-Face* and *Tales of Secret Egypt*. Whilst trying to track these quirky classics down, I came upon the name Harry Stephen Keeler and was at once captivated by the utterly bizarre titles of the dozens (!) of mystery novels he wrote from the twenties to the early fifties. With titles such as *The Voice of the Seven Sparrows*, *The Green Jade Hand*,

*The Spectacles of Mr Cagliostro, The Barking Clock, The Travelling Skull*, etc., etc., who could resist finding and reading these bizarities from a bygone era?

What the publishers Ramble House have done over the last few years is reprint ALL Keeler's novels in trade paperback format, along with producing minutae on their website, and important marginalia like this present volume, BEST OF 10 STORY BOOK. This was a 'spicy' pulp magazine which Keeler edited from 1919–40, replete with zany, sometimes downright bonkers, stories from pulpsters of the time , such as Jack Woodford, Theodor Pratt, August Derleth, Tiffany Thayer ( founder of the Charles Fort Society), and Keeler himself. The result is a fascinating peak into a forgotten era of charming sleaze and madcap humour. The book also reprints some of the illustrations – often photos of scantily clad ladies – which accompany short tales with titles like: 'The Man with the Odd Skull,' 'Death Spiders,' 'The White Man who Turned Black' and 'The Blue Eyed Gorilla'...

The *Best of Ten Story Book* is edited and introduced by Headpress alumnus, Chris Mikul. Ramble House have also recently published a volume of Chris' own oddball stories, *Tales of the Macabre and Ordinary*, $18.00, 175 pps, 2007. Like *Best of 10 Story Book* it has no ISBN and can be best ordered from the Ramble House website: ramblehouse.com. [SS]

# News that's fit to print.

## by Caleb Selah

THE HEADPRESS Service Engineer on his "big three" of 2007:
MR SLY STONE, MR GARTH HUDSON and MR JOHN SINCLAIR.

## STONE

FIRST OF all a warning to you pitiful tiny minded crackerbreathed honkie scum who witnessed MR SYLVESTER and his FAMILY STONE at the beautiful Boscombe Opera House. At this particular gig service levels were low, i.e. the desk of sound was most unsound. This was why the gig may have seemed bad. Booing the band was not the best way to get this gig moving, my friends. Imagine the scene in the dressing room: *"Yo Sly, there are a load of uppity white limey motherfuckers demanding you get your ass out there."* We were lucky to have seen him at all. The crimes at the time were a lack of competence behind the desk and too many idiots just there for an afro and Family Affair. The whole gig had been promoted chicken in a basket style but we miss the point. He was back. For him to appear sans chaos was unlikely, and you may recall me and a number of my colleagues hunting you down at the aftershow party trying to tell you the REAL STORY, which was we shared the same air as a god, who for five years was the epicentre of the rainbow ethic that revolutionised music for ever: from Clinton (not that one) to Miles; interracial, intergender and in-to-drugs indeed. If you want a taste of the great man's return (and he was not the only septuagenarian to rock Headpress' world in 2007) go you tube sly north sea 2 and listen to him ooze a note perfect blues drenched performance of his rejection of the music businezz: "If You Want Me To Stay." If indeed we do want him to stay, audiences have to police the huge cracker element themselves. The sort of jerks that boo a band when there aren't enough mic leads and at no point have the intelligence to comprehend that the

man behind the big desk with the knobs is mainly responsible for GETTING THE FUCKING SOUND RIGHT.

I apologise, as a service engineer, for picking a fight with someone who was into Sly and merely trying to protect his girl from my over enthusiastic elbows. I digress, it was a pleasure almost beyond description, Sly, to see ya standing, singing simple songs and reminding us that someone is watching us. Thank you for being yourself again. And shame on you if you were amongst the sinners trying to get your money back whilst the man was still on stage.

Suckers.

# HUDSON

AND THEN to the 100 Club Oxford Street W1, on a drizzly night where smokers first begin their miserable huddling outdoors to witness an atheistic miracle. The previous night I had managed to get JERRY SADOWITZ to switch from a "yes" to a "no, I don't want to do a secret guest appearance at a Headpress launch." So, depressed, I took solace in The Band's website (yes that band, Dixie, Bob Dylan, *The Last Waltz*). Sensing my deep sadness the site told me that GARTH HUDSON and his beautiful wife MAUD would be playing for our listening pleasure that very night (Mr Sadowitz had finally pulled out at 3am eternal). Wow, yes tickets were still available, so with roving reporter MR HARDING and foxy service engineer MS L STANTON in tow we tripped the light spastic.

"We will find him and I will do the talking," said Mr Harding. Both of us were in the grips of terrible midsummer hay fever so I merely nodded at the unlikeliness of his statement, recalling how little Mr Hudson had offered up to Mr Scorsese in the Last Schmaltz of Mr R Robertson. Then, in the toilets as I nodded the end of my "yeah as if" nod, Mr Harding gesticulated at one of the cubicle doors. "He is in there." I accepted this fact grimly. The mad professor of the musical 1960s himself walked out and began to wash his hands. Mr Harding leant into him and began to incant words that I could barely make out and meant nothing to me. Our roving reporter was going to blow it. Don Metz, Turk Broda, Sweeney Schriner, Frank McCool. Strangely, Mr Garth Hudson was not only paying attention but was straining to come to terms with whatever voodoo Mr Harding was trying to lay on him. After three or thirty minutes the bizarre exchange came to an end.

"What the fuck were you saying to him," I spluttered.

"You don't need to worry about that, watch this," and we both strode purposefully over to the dressing room area, which was patrolled by a singular old white guy.

"We want to see Mr Hudson."

"I am afraid you can't see him before the show."

"Then tell him these two gentlemen wish to speak to him after the show," and Mr Harding scribbled two names on a piece of bus ticket. "He will want to speak to us."

The flunky vanishes within and returns two minutes later to tell us that, although Mr Hudson seriously suspects one of us

may well be dead, he will indeed talk to us after the show. The nature of the incantations and names on the bus ticket are then revealed to me: famous 1940s Canadian ice hockey players. The gig is Garth and a few young English guys pounding out everything from Ain't No More Cane to a heartrending It Makes No Difference, with Maud singing some exquisite blues from the depths of her magic chair. The magic spreads as she asks me, "Take care of Virgil for a while" and passes to me her beautifully crafted walking stick.

"Virgil?" I ask? "Dante."

"No, Virgil Cane," says she. "Levon gave it to me." (See The Night They Drove Old Dixie Down, www.theband.com) At the end of the gig Garth and Mr Harding get down to conversing things dead, Canadian and icy whilst I mess about with Maud laughing at the things people ask to write for autographs. *"Dear x, I have loved and known you all my life, Maud xx."*

So thus far we have the sly ebony and the ivory irony. What else could there be...?

breathing the defiant air of the Headpress Bunker, ladies and gentlemen please welcome to the ring MR JOHN SINCLAIR. (Go to Wikipedia, I am not it.) This man was out there building the fucking barricades with his bare hands, chasing Nixon and his packrats down to earth despite the impossible odds and winning. Only then to see Bush crawl back and apathy is renamed ambition. Ah, for all good black men Europe offers hope and respect like a thorny olive branch. But thank you Lord for sending this man our way. We will use him well and care for him whenever called. We accept the seriousness and the weight of the baton that has been placed in our hands.

My best memory of the year? Standing in the cold outside the Chomley Boys Club, the venue of forty first birthday/first wedding anniversary celebrations, with the blackest of panthers at midnight waiting for a never to come taxi, dancing next to a cold black London lamppost in the bleak black London night when out of nowhere Mr Sinclair croons Mama Roux as a charm to ward off the cold and to make me feel like the proudest man on earth.

# SINCLAIR

COULD THE year get any better? Still reeling from the entry of Mr Zimmerman's Modern Zimmerframe album into our lives walks the man Headpress, and indeed the world, has been waiting for without really knowing it. A real heavyweight. A bear of a man, the twenty-to-life panther, the ten for two for tower of power in our house smoking our weed

The Great Fire of Dalston

A beauty parlour had been burning for the
better part of the day on Kingsland High Street
when the story reached us back in the Bunker.
The cause of the fire was a lady who had a
makeover and exploded with beauty. By the time
we arrived all that remained was a pair of
calcified track pants and pedicure utensils,
which were not completely destroyed but
worthless all the same.
In a pub around the corner that was once the
de Beauvoir Arms, the new landlord imparted
information with a tap of his nose. He was
out of snacks until Tuesday, he said, but
had removed the troublemakers from the pub
and we wouldn't be seeing the likes of them
here again. He said this as he threw fellow
Headpressman Dylan a look that suggested Dylan
was on borrowed time for talking too loudly
into his phone. A man swayed at the bar with a
bottle in his hand, yelling "Hello beautiful!"
at anything that moved.
The troublemakers were gone all right. No more
Lighthouse Family on the jukebox, responsible
for so much consternation in the past and at
least one episode of fisticuffs. In their place
was a talent scout on a barstool ready to fall
down and a television tuned to the soaps.
"What do you know about this fire?" I asked
Professor Soledad.
"FIRE?" barked the professor, a flagrant
disregard for the quiet zone. "I don't know
about any fire."

Now read on...